History of Art

History of Art

Second Edition

MARCIA POINTON
Reader in History of Art
University of Sussex

London
ALLEN & UNWIN
Boston Sydney

© Marcia Pointon, 1980, 1986

Allen & Unwin (Publishers) Ltd,
40 Museum Street, London WC1A 1LU, UK

Allen & Unwin (Publishers) Ltd,
Park Lane, Hemel Hempstead, Herts HP2 4TE, UK

Allen & Unwin Inc.,
8 Winchester Place, Winchester, Mass. 01890, USA

Allen & Unwin (Australia) Ltd,
8 Napier Street, North Sydney, NSW 2060, Australia

First published in 1980
Second edition 1986

British Library Cataloguing in Publication Data

Pointon, Marcia
 History of art: a students' handbook.—[2nd ed.]
1. Art—Historiography
I. Title
707'.2 N7480
ISBN 0-04-701016-9

Library of Congress Cataloging-in-Publication Data

Pointon, Marcia R.
 History of Art.
Bibliography: p.
Includes index.
1. Art—Historiography—Handbooks, manuals, etc.
I. Title
N380.P56 1986 709 85-30607
ISBN 0-04-701016-9 (pbk. : alk. paper)

Set in 11 on 12 point Garamond by Paston Press, Norwich
and printed in Great Britain by Thetford Press, Thetford, Norfolk

Contents

For Thomas and Emily

Acknowledgement

The cartoon by James Thurber on p. 5 is published by kind permission of Hamish Hamilton Ltd., from *Vintage Thurber*, Vol. 1 and Mrs Helen Thurber © 1966 Helen Thurber from *Thurber & Company*, published by Harper & Row.

Preface to the new edition

Since 1979, when the first edition of this book was written, Art History has been the focus of critical attention. The debate about the discipline, its legitimate objects, its proper boundaries, goes on. The politics of museum management and higher education may not have made the kinds of questions posed in the first edition of this book any easier to answer. But nor have they made them any less pressing. This book was originally written in response to the spread of interest in academic Art History beyond its traditional boundaries, as an aid to sixth-formers and students. There was, then, a real need to break through the barriers of professional mystique on the one hand and widespread educational ignorance on the other.

The situation in 1985 is in some ways different. More people certainly now know that there is something called Art History, a scholarly and intellectual practice that addresses the history of art. What is much less clear – especially among art historians themselves – is what precisely Art History should be doing. In polytechnics and in universities, in journals and in the press, at conferences and symposia, the effectiveness and functioning of visual imagery is more than ever a topic of hot debate. The museums and art galleries have moved at a more dignified pace but there too there are signs of change. There is no doubt that for most people, whether they count themselves as so called 'New' art historians or whether they see themselves as a conservative rearguard, the map of Art History now looks very different.

This completely revised edition of *History of Art: A Students' Handbook* does not seek to be polemical; the object is as always to convey information about what students may expect to encounter. Identifying areas of study, methods and objectives is what is being aimed at. Of course, it would be disingenuous to pretend that there is no authorial point of view. I have, however, tried to concentrate less on justifying one procedure, practice or methodology as opposed to another than upon trying to elucidate

what those procedures, practices and methodologies comprise and how they connect.

The task of writing a text such as this, however modest its appearance, becomes ever more daunting. It may seem paradoxical to write about Art History as a discipline when many of the traditional boundaries between the Humanities are being ruptured and reconsidered. It may be said that I have not argued in defence of Art History in the curriculum but have assumed it to have a rightful place. In the first instance the shifting boundaries between disciplines does, it seems to me, make it all the more imperative to describe and analyse where we are now; the description cannot be comprehensive but it is based on the common experience of students. In the second instance, I do not see this handbook as the appropriate place for a defence of Art History. Nevertheless in identifying what I perceive art historians to be doing, and in particular by discussing the different possibilities for Art History in relation to other disciplines, I am quite clearly affirming what I regard as the central role of the discipline within cultural history and drawing attention to the significance of its place within the Humanities.

Brighton 1985

1
Experiencing Works of Art

We live in a world of visual communications: television, films, videos, advertisements, signs and symbols in public places and at work, graffiti on buildings, photographs in tabloid newspapers, pictures in the National Gallery, serial strips and cartoons, packaging on consumer goods. These things in whole or in part belong to our everyday cultural experience. None of them is outside history; all are forms of communication determined by how we live now as well as by what happened in the past. Visual culture spans a vast range of experience, therefore, from the label on a canned food product to a Rembrandt self-portrait in the National Gallery. Art History is concerned with exploring these experiences within history, with analysing them in order to understand how they are composed or constructed and with recognizing them as carriers and producers of meanings within society and in relation to other forms of communication.

Art History has long been associated mainly or even exclusively with High culture as visually experienced, that is with Rembrandt rather than with record covers. So it is not surprising that for most people the art historian is someone who appears briefly in the public arena to make a definitive statement about a work of art on the occasion of a spectacular theft from a famous art collection or when a record sum is attained at one of the big London auction houses. The scholarly world of Art History may seem to have little bearing on what most of us enjoy when we encounter what we recognize as works of art. We may treasure the recollection of our first sight of a painting by Leonardo da Vinci or a metal sculpture by Anthony Caro. We might buy a catalogue or a book to find out more. But we don't think of this in connection with Art History. For most of us the art historian is a person who

defends in a specialized jargon the purchase out of public funds of apparently absurd objects in the name of art and who writes long catalogue entries which, when we read them, seem incomprehensible and irrelevant to our experience of looking.

Art History can, however, convey to us factual knowledge about the history of art, about how the Leonardo or the Caro came to be produced, about the context in which it was created, about the meanings it had for the audience to whom it was initially addressed. But Art History also tries to explain why we respond to these things in the way we do, why we think of Leonardo as art and an advertisement as not art. Art History can help us see more widely and more clearly but above all it can help us to understand the connections between different areas of visual experience, between Rembrandt and a record cover, and it can make us more conscious of how visual communication functions and is employed in societies both past and present.

People who enjoy paintings are sometimes reluctant to analyse them for fear of spoiling the richness and spontaneity of their experience. It has been suggested that some of the recent work done by sociologists and social historians in Art History ignores and indeed denies the aesthetic experience, the fundamental pleasure of looking. This view is a bit like the notion that knowing the ingredients of the recipe, recognizing the method of cooking and seeing the utensils used detracts from the taste of the dish. But Art History does more than this; it seeks to explain why (to pursue the metaphor) certain foods are favoured in certain cultures, what the differences in cultural meaning are between, say, fish and chips eaten out of newspaper on a wipe-clean kitchen table and smoked salmon served in a silver dish on a polished mahogany surface.

Acknowledging the importance of enjoying something does not, of course, preclude an historical analysis of the object that is arousing the pleasure. It might in fact become more pleasurable if we know more about it. Moreover pleasure is itself historically located. Why we like particular characteristics of certain sorts of objects at any one time is not simply the result of our genes or our own particular personalities but is determined by values promoted within the society of which we are a part. So, while no one seeks to underestimate the importance of sensuous and instinctual responses to art objects, the notion that the sensuous is undermined by the intellectual is a legacy from a period in the past which promoted art as an alternative to thought.

In fact we unknowingly engage in forms of visual analysis that are a basic part of Art History all the time. Whenever we deliberately and consciously choose a style that we know to be of the past (a William Morris type fabric, a thirties style tea cup or a fifties tie) we are applying aesthetic and historical criteria as well as functional values. We are motivated by an awareness of the symbolic as well as the utilitarian: a stereo set with a readily recognizable tape deck, a pine bath rail instead of a stainless steel one, a purple Citroen Dyane instead of a white Ford Escort. Each time we stand any length of time before a painting and find ourselves stimulated and provoked to think, to ask questions, we are engaged in art appreciation. Every time we look at a painting and then, moving to look at the one which is hanging adjacent to it, find ourselves noticing that it is different or similar in some way, we are involved in analysis. Art appreciation necessitates learning to look and we cannot become art historians until we have become art appreciators.

Learning to look is not easy but it is enjoyable and, for many, results in a life-long fascination with visual experiences. Many of us are able to say with conviction and sincerity that we like art but would find it extremely difficult to say precisely what we like and why we like it. Even when we plan to visit an art gallery, we find ourselves confused, unable to fit things together – though we may be aware that there is a tantalizing pattern which we cannot identify – and, above all, we find it impossible to express adequately in words what our experience of looking has been like.

As children, we learn to draw before we can write but very soon literacy and numeracy become through school the criteria of our achievement. Only when we look into the children's dental clinic and see the walls covered with posters of crocodiles with bright, gleaming teeth and rabbits nibbling nuts, or when confronted with a photograph showing the lacerated face of a car crash victim who was not wearing a seat belt, are we reminded that in some cases the pictorial image is more powerful than words to convey to us a complex mass of associations and ideas. Art History requires us to regain and cultivate our ability to respond to all visual expression in whatever form it may appear.

If you think looking and seeing are simple and straightforward matters that are instinctive to everyone, try looking at a picture and describing what you see. Or, even better, look hard at a picture, a building or a sculpture and then go away and try to

remember precisely what was before you and what it meant to you when you looked at it.

Liking art and feeling that it stimulates us intellectually and emotionally is, of course, the first stage. It is, however, only a beginning for the art historian whose concern extends beyond immediate appreciation to recognizing signs and decoding pictorial messages in a historical context. We have to be historians as well as art lovers and this involves us in the consideration of many things besides paintings and other artworks. We must have, in fact, at our disposal both the ability to respond to colour, line, composition and all the elements that go towards a visual experience *and* the resources of the historian as well, including his or her ability to interpret the events of the past.

Thurber's witty cartoon is a clever inversion of the usual 'I don't know anything about art, but I know what I like', the layman's defence against the 'expert'. Just as liking is a vital part of knowing, so knowing is essential to liking. It is the relationship and the developed, cultivated balance between the two that is difficult to achieve. In *Pride and Prejudice*, Jane Austen's heroine, Elizabeth Bennet, visits a great historic English mansion. She knows that the apartments are full of 'good pictures' but she walks past them in search of something with which she can identify on a personal level. This is an experience familiar to most of us to some extent or other at some time in our lives.

There are many forces at work that make it difficult for us to experience immediately and directly the works of art in museums. Though an awareness of why we like certain visual objects may help, the knowledge that authorities have said that a certain object is 'important' can make us, the uninformed viewers, feel excluded and inadequate. The institutional atmosphere that still, alas, prevails in many galleries and museums can be very daunting. The implication of Thurber's cartoon, that it is as important and as difficult to like as it is to know, is a salutary reminder to critics and to art historians. Nevertheless, the all too frequently encountered anti-intellectual attitude enshrined in the 'I don't know anything ... but I know what I like' philosophy is not merely foolish but actually destructive. The business of 'looking' must be a serious discipline. It is both a routine in which prejudice plays no part and a cultivated practice which nevertheless permits surprises.

The fact that slides, photographs, books – however instructive – are never a substitute for directly experiencing visual works of

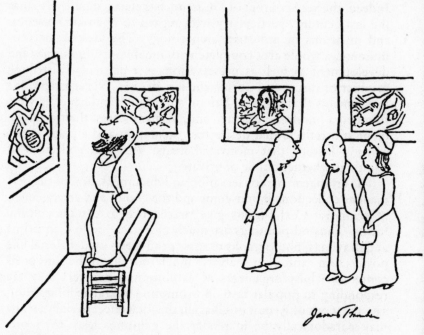

'He knows all about art, but he doesn't know what he likes.'

art can never be too often reiterated. It must also be said, however, that looking can be difficult. A glance around, say, the Hayward Gallery on a Sunday afternoon shows that while great numbers of people desire to acquaint themselves with works of art, few of them actually spend more than two or three seconds before any single object. Occasionally, sheer exhaustion overtakes the viewer who sinks into one of those symmetrically placed, black, plastic-covered chairs that are a characteristic of today's galleries, and gazes dully ahead before regaining a place in the queue that moves slowly along the numbered rows of exhibits towards the exit.

'Pictures are for use, for solace, for ornament, for parade; – as invested wealth, as an appendage for rank. Some people love pictures as they love friends; some, as they love music; some as they love money.'[1] These words were written well over a century ago but they are still relevant today. During the last ten years, many new ideas about the function and the arrangement of galleries and museums have been discussed and put into practice.

Indeed, the very concept of a museum has changed radically since the last century, particularly with regard to open-air museums and museums of industrial archaeology. The idea of the eco-museum, a whole area complete with inhabitants, industries and development as well as preservation, is a particularly striking product of discussion during the last decade. Nevertheless, the fact remains that many of Britain's museums and galleries were founded a hundred years ago and, in many cases, their arrangement still reflects that desire for ostentation and a ready-made cultural history that motivated many Victorian collectors of paintings whether public or private.

The arrangement, conservation and documentation of the permanent collections in museums and the choice and arrangement of temporary exhibitions give precedence to certain cultural forms. Thus oil paintings are much more accessible than prints and drawings, photographs or mass produced visual material like posters. An exhibition is always much more than the sum of its contents; whilst organizers of exhibitions often feel they are responding to popular taste in promoting a large exhibition of, say, the work of Renoir or Chagall, the total effect of such a show may paradoxically be to render the paintings less, not more, accessible. Backed by prestigious industrial sponsors, displaying and cataloguing popular favourites, the exhibition severs such artists from their community and time and enshrines them in a Temple of Art where carefully inscribed labels convey to us a reading assumed to be the single and correct interpretation for each work and arrows tell us where to commence and where to finish.

Nevertheless, exploring buildings, getting to know works of art, discovering artefacts from the past and developing a critical spirit in relation to the changing appearance of our environment should be central to the experience of a student of Art History. This chapter offers advice and information of a practical nature to enable students to engage profitably in this activity.

Perhaps the most important single thing to remember is that even though a house built by E. Maxwell Fry in Hampstead cannot be moved to Hull for inspection and a loan exhibition of fifteenth-century Flemish altarpieces may only be seen at the Royal Academy in London, almost every area of the country offers something of interest to the art historian. Knowing one's own locality, discovering works of art in local collections, getting to know the work of a local architect or a designer, identifying the

idiosyncrasies of a local collector, making a study of any location where visual communication is important (such as a railway station or a department store), these may be as worthwhile for a student as devoting quantities of time and money travelling to London for a special exhibition. While it would be absurd to deny that there are certain events which should be regarded as priorities and which it is worth making enormous efforts to see, the extent to which a journey to London or some other large city to see a 'once in a lifetime' retrospective exhibition or centenary show is rewarding will be largely determined by how much has been learnt about looking and analysing with material available locally.

Most of us are astonishingly ignorant of the wealth of visual art available to us within walking distance of our homes. There are many ways in which it is possible to become informed about what to look at and what to look for. A notebook and pencil to be carried at all times are basic equipment for an art historian. A quick sketch of an architectural detail, a note made of a painting seen in a sale room or a public place, an analytical drawing of the particular layout of a page in a newspaper or illustrated magazine, help us to develop a good visual memory and may be useful in providing the focus of a piece of research in a local library. Writing down what you notice about the object you are looking at is, probably, the most efficient way of learning to direct the attention and of acquiring the habit of posing questions even if no answers are immediately forthcoming.

A gallery or a museum is not, then, necessarily the best place to start to learn about looking for those very reasons of historical and cultural association and background that we have already mentioned. However, in many galleries and museums, there is nowadays someone specially responsible for what is loosely termed 'education'. His or her activities usually range from providing lectures to groups of adult visitors to liaising with local schools about the most effective use of the resources.

No museum or gallery ever has all its collection on display at once and it is normally possible to see objects from the store provided notice is given in advance. The treasures housed in public museums and galleries belong to everyone and, whilst one of the curators' and keepers' responsibilities is that of safeguarding, researching and improving collections, it is equally their responsibility to answer questions from the public and to help people to acquaint themselves with works of art.

Increasingly curators are sympathetic to the notion that one

can only know a Mies Van Der Rohe chair by sitting in it or a
sculpture by touching it and handling it. Clearly there is a
problem here. If everyone wanted to experience directly delicate
items in collections, the function of the museum as guardian
would have to take precedence over the function of the museum
as educator. But in general requests from serious students who
have done their homework (especially if they are addressed in
writing rather than delivered verbally on the spur of the moment)
are sympathetically received.

The staff of provincial museums and galleries frequently have
at their disposal useful information about artworks and buildings
of interest in the area covered by their museum's service. For
obvious reasons of confidentiality, they are not always willing to
impart this information, but it is certainly worth approaching
them for details. Other important sources of information are local
history libraries (usually a department of the central municipal
library) and country record offices. Organizations like the
National Trust and the Victorian Society will provide information
about buildings of interest in your area. If there happens to be a
site of special historical interest in the locality, this may be
covered by the activities of a local civic society or preservationist
pressure group. By joining one of these groups it is possible not
only to gain access to art-historical material that may be experi-
enced at first hand but also to do a useful job for the community
and acquire expertise in research, records and presentation. For
those working in mediaeval art, local archaeological societies are
often a fruitful source of information. A list of names and
addresses of organizations and groups is to be found at the end of
this book.

It is advisable, having selected an area of study, to narrow it
down as much as possible. It is usually more rewarding to get to
know one Norman church in your area or one aspect of the work
of an artist than four churches or the whole of one person's work.
In the same way studying one painting in a gallery rather than a
room full of pictures is the best way to learn about looking and
knowing.

It may be that what you have chosen requires no special access;
an analysis of the visual arrangement employed to attract custom-
ers into a competitive market and an evaluation of the meanings
and associations produced in that arrangement (baked beans by a
certain manufacturer equals a happy childhood; a brand of tights

makes you a real woman) might require only several visits to a shopping centre. A study of style in clothing of any given group would require a very clear definition of that group (punks on the promenade at Blackpool; shoppers in the food department at Fortnum and Mason).

Practical considerations are important. Plan a programme of work including several visits to a site, some relevant reading and consideration of the method and approach to be used. If relevant ascertain opening hours before setting out and, if your destination is a church or you are likely to want to see something not normally shown to the public, write in advance to the vicar, the curator or the estate manager to request permission to view your chosen material. It can be particularly frustrating to reach a remote country church to find it all locked up and the vicar away on holiday or visiting in another parish. Certain objects or groups of paintings are only shown at certain times of the year. The National Gallery of Scotland only shows its Turner watercolours in January when daylight (which is a destructive agent to which watercolour is particularly subject) is weakest. Avoid peak holiday periods if possible and choose clear bright days. The stained glass in a church will not be seen in all its brilliance on a wet, dull day and although many galleries are now completely artificially lit in the interests of preservation, there are still major picture collections housed in galleries with huge glass roofs and, in these cases, the better the natural lighting conditions the better the experience of looking. Some documents, like newspapers and journals, are now available to the public only on microfilm so it is important to book your visit in advance and reserve a place on a microfilm reader.

A preliminary look at your chosen object will not only help you to establish a visual relationship with it but will also assist in identifying the questions that need to be asked about it. Go away after an initial session and work out a questionnaire or a series of headings under which to work. The discussion in Chapters 2 and 3 should help you to direct your study. Some initial introductory reading may help though it is as well not to become too involved in the literature at this stage. You will, in due course, want to read what others have said and learn more about the subject but you will come to the literature with a more critical mind if you have sorted something out for yourself first.

Art historians need equipment; geologists take hammers with

them when they go out on field work and entomologists take nets. A hard-backed notebook of the type that has one page lined and one page blank can be very useful for the kinds of recording I have described earlier. A camera is often an asset, though it may also be a great nuisance. Not only can it be exhausting and inconvenient to have to carry around a lot of heavy photographic equipment but, more important, there is a danger that the camera will make you more intent on taking the photograph than on looking at the object. Indeed there is a danger of actually seeing a work of art in terms of what would make an attractive or striking photograph. For this reason, photography should be regarded by the art historian as strictly for recording purposes and it should come in only at the final stage of looking. There is a lot of footwork involved in looking, whether it be in a museum, in a city centre or in the countryside. It goes without saying that comfortable shoes can make all the difference to the day and if you happen to be exploring Stourhead Gardens in Spring or Kensal Green cemetery in winter, wellington boots are a necessity.

A tape measure is a useful piece of equipment for the art historian. A dressmaker's tape measure is very convenient for measuring the dimensions of paintings or drawings and also for recording the girth of a column. A pocket magnifying glass and a pair of binoculars can be very useful too. It may perhaps seem that these things are superfluous for someone who is not writing a definitive study or making some kind of report. But the fact is that knowing a work of art (whatever the medium) should involve a comprehension of it as a three-dimensional object, as something fully concrete and existing in space.

Obviously, to look at stained glass only through binoculars is never to see it as it was intended to be seen. On the other hand, however, the full quality of colour and the effectiveness of technique cannot be appreciated without a closer look. The art historian wants to know not only what it is but also how it has been made. Similarly, the magnifying glass is not only used by art historians to authenticate a work or to examine a signature but can assist towards knowledge about how a picture was painted.

Looking at buildings requires a different discipline from looking at sculpture, paintings and other art objects. It is important to take into account considerations like the season and the weather and the time of day. Is the building being seen under typical conditions? This is an important question. The relationship of a

building to its surroundings, whether natural or man-made, might appear different in winter from in summer. At certain times of the day architecture, particularly public buildings, has a more obvious function than at other times. If you are visiting an office-block, study it as a working, active edifice rather than as a place in repose. Make sure you know what it feels like at 9 a.m. and at 5 o'clock in the evening when those who work there are arriving or leaving.

The relationship of exterior to interior is fundamental to architectural study. It is necessary to do more than merely look from the outside. Request admission and move about inside the building. Find out what the experience of the building is for those who work in it and for those who use it, for the people who travel in its lifts, deliver material to its loading bays or look out of its windows. Is life in the building easy or difficult, unpleasant or agreeable? Consider the structure as a whole, taking into account the furnishings and the fittings as well as the actual fabric.

Many modern buildings take on a quite different appearance with the introduction of human movement and colour. The University of East Anglia presents an unyielding and mono-chrome face to the world during a vacation but in the middle of term its concrete ramparts are enlivened by masses of moving figures. The needs and characteristic patterns of movement of the population have to be taken into account when studying architecture. Sometimes, for example, it is possible to observe that, in laying out paths and walk-ways, the architects or planners have made inappropriate or inadequate provision for the consumers and the scarred turf or broken balustrade bears witness to the pedestrian's natural routes.

In cases where alternative use has been found for a building (cinemas and churches are now frequently in use as anything from private houses to book-stores), it is important to arm oneself with the clearest possible information about what it was like in its original state.

In looking at sculpture, one of the most important consider-ations is where the sculptor intended the work to be placed. Column figures from Gothic cathedrals have found their way (in the interests of preservation) into museums where their precise function and their role as part of a total structural concept has disappeared. Monumental sculpture, which may have been seen, when *in situ*, from a hundred feet below and which was, therefore,

designed to be seen in daylight from a distance, may now be placed in artificial lighting in a cramped corner of a museum.

Even sculpture which was never intended for any specific location is more meaningful if we ask what environment the sculptor intended. Henry Moore envisaged an outdoor open-air setting for much of his sculpture whereas Anthony Caro has often let it be understood that he wants his work to be viewed in an enclosed, empty space.

Naturally it is necessary, when looking at sculpture and architecture, to be conscious of the changing viewpoint. Walk around and examine the object of your attention from every side. Touch it, feel it, look through it, above it and below it. If the sculpture is placed out of doors, make sure you see it in different weather conditions. A bronze by Barbara Hepworth looks quite different when it is sleek and shiny with rain from when it is gleaming dully on a sunny day.

With works of applied art, it is especially important to see the object in its appropriate surroundings. This can be problematic. A chair or a length of textile conveys a different visual message to the viewer according to its setting and according to the nature of the objects placed around it. One Biedermeier chair may be a beautiful object on its own but its special characteristics of design and the way it works visually can only be appreciated if it is seen in historical context, that is, in a total Biedermeier interior. Unfortunately it is seldom possible to do this but one can go some way towards establishing the relationship of an object to its surroundings. If you cannot, for example, view a Lalique vase in a contemporary setting, then try to find an art nouveau interior of the period to which the vase belongs and study it alongside the object. Failing that, there are always photographs and descriptions which may be a considerable help.

Finally we come to the problems of visiting those large national collections of art and the temporary high profile exhibitions which we have already mentioned. Inevitably, we often find ourselves having to push a great deal of looking into a short space of time. There is little one can do about the disadvantageous conditions under which much looking in large galleries has to take place. There is no doubt that stamina and the ability to absorb a great deal in a short space of time are great assets to the art historian. It is also true, however, that a shorter, planned visit is more worthwhile than one in which you try to see every room in

the gallery in one day. There are several rules which, however obvious, really are worth remembering. In the first place, if it is a question of a temporary exhibition, go early. Nearly all such exhibitions become impossibly crowded as the final day draws near simply as a result of press reviews and the word being passed round. In large national collections do not try to see every school (paintings are still usually hung in national and chronological groupings) or every picture within one school. Consult a plan of the gallery beforehand and, if possible, study the catalogue beforehand. You may change your mind when you get there and find yourself so impressed by something you had not planned to see that you devote all your time to it. This is all well and good but planning your visit before you set out remains a useful practice.

Note: Chapter 1

1 Mrs Anna Jameson, *Companion to the Most Celebrated Private Galleries of Art in London*, 1844.

2

Art History as a Discipline

In this book we shall try, without smoothing over the differences and complexities, to point to possible ways into and around the discipline of Art History. It is to be hoped that we shall not lose sight of the experience of the visual that was our starting point for it is all too easy, having been initially excited by seeing a painting or a work of art of any kind, a vibrant, sensuous, three dimensional object with its surface texture, its subtle tone, its quality of arousal to forget (as we sit in libraries with our heads buried in books, saturating ourselves with colour plates and sundry information) what was so special about the experience in the first place. Thus we shall, in later chapters, see how we can most readily discover what we want to know and examine ways of organizing our looking at pictures and our reading about them to the best advantage.

Let us, first of all, look at what the education system offers because the whole subject is very confusing for those who are wondering whether to take a degree course in art or pursue the study of Art History on their own or in a further education class. To begin with, 'fine art' is a term which has often been used in the past in a general way to describe painting, music, drama, sculpture and other art forms. In this sense, the fine arts are those that are distinguished from the useful or mechanical arts. If a university has an institute or school of fine arts, it is likely that Music and Art History will feature large in its programme. But degree courses in Fine Art in Britain are nowadays by and large those in which the student spends some of his or her time in the studio 'doing' art and the rest of the time looking at and studying other people's art. These courses are, therefore, quite different from History of Art or History of Art and Design and Film degree courses (whether

14

in polytechnics or universities) in which students are not formally engaged in practical work. Art historians have been and still are on occasions both scholars and makers of art.

It is sometimes said that only those who make their own art can really give an authoritative view of the art of the past. Those who hold the opposite point of view believe that the discipline of Art History in itself is a creative activity and that those who are also artists as well as art historians can be wholly committed neither to the one nor to the other.

What none of us can deny is that artists have always studied art and creatively exploited the work of their predecessors. The contemporary artist Francis Bacon has acknowledged a long-standing preoccupation with a number of images from the past among which is a famous portrait of the Pope by Raphael. The American Pop artist, Red Grooms has recently deliberately parodied celebrated images from French nineteenth-century painting in his *Liberty* and in his creation of agricultural implements inscribed with images drawn from the rural paintings of Millet. Sir Joshua Reynolds 'quoted' from the famous antique statue of the Apollo Belvedere in his portrait of Viscount Keppel in the eighteenth century; and when we recognize Henry Moore discovering and utilizing powerful non-European ways of depicting the human form or Degas reproducing a picture by someone else as a point of reference within his own painting our experience of looking and understanding is enhanced and we are also witness to the continuing creative process of art.

The issues raised by this discussion are clearly of relevance to today's students of art. For them the controversy centres not surprisingly on whether art students can be 'taught' the art of the past or whether they have to discover unaided what might contribute to their own effort to create. But the teaching of the history of art to students of practical art in polytechnics is based, rightly or wrongly, on the assumption that a helping hand, a discipline within which to organize encounters with works of art, the proffering of material the student might not otherwise come across, is generally enriching and can be directed specifically towards the individual's own area of artistic practice whether that be ceramics or graphic design.

Design History is a discipline within its own right and a specialized literature in connection with the subject is growing fast. Studying the history of the design of useful objects, especially

those which have been little influenced by the development of pictorial art, is now a richly productive area of teaching and research in polytechnics and schools of Art. The teaching of non-European art tends to be concentrated in institutions with special resources so if you have a particular interest in Pre-Columbian or Chinese art it is important to check in prospectuses to make sure that courses are offered in those areas.

To sum up briefly, all art students in polytechnics and art colleges do some Art History and many make a special study of Design History. The precise weighting of a course between practical and historical studies can often be varied according to the student's disposition and abilities. Some polytechnics also offer History of Art, History of Design and History of Film courses. Some universities offer film and communication studies also as degree subjects. Sometimes a School or a Department in either a polytechnic or a university will bring together a range of courses on visual communication under the heading of media studies or communication studies. In universities and in polytechnics there are opportunities for studying the history of art on its own or as a component in a Humanities degree either on an equal basis with other disciplines, through a major and subsidiary component or, sometimes, on an interdisciplinary basis. Fine Art in a university often means studio work and studies in the history of art combined. Courses vary greatly as to entrance requirements (some institutions, for example, insist upon a modern language) but by and large nobody insists on an 'A' level in Art History though some people regard it as useful.

Before proceeding further, a few words need to be said on the subject of Design History. Were we to address ourselves to this discipline as well as to that of History of Art, this book would run to twice its length and a whole separate frame of reference would be needed. Nevertheless, art historians should not neglect or ignore the applied arts and manufactured objects. Paintings, china, furniture and mass produced items are housed together in museums and, although in all but the smallest museums, curators specialize in the care of one or two aspects of a collection, the overall responsibility is normally one person's. Not only are the applied arts and crafts vital to an accurate view of an age but they are essential to an understanding of the work of many individual artists. We cannot fully appreciate John Flaxman the sculptor and draftsman without John Flaxman the designer of 'Etruscan'

tableware for Wedgwood. The relationship between embroidery, which has been for hundreds of years considered as a craft inferior to painting, and the so called high art forms of drawing, painting or sculpture is necessary if we are to arrive at an accurate view of the changing conditions within which women and men practised a variety of art forms.

It sometimes happens that an artist exploits in one work both traditional craftsmanship in the production of useful objects and the sort of learning and visual arousal associated with oil paintings for a large public. Judy Chicago's *The Dinner Party* is a show which combines documentary research (the histories of 'great' women researched by a team of workers) and a spectacular visual display comprising individual place-settings around a three-sided dinner table of vast proportions made in the media traditionally associated with women's work. Andy Warhol is one of many contemporary artists who use techniques of mass reproduction (photography and screen printing, for example) in the production of a 'one off' art work.

Art History is concerned with no single class of objects. Every 'man-made' structure and artefact, from furniture and ceramics to buildings and paintings, from photography and book illustrations to textiles and teapots comes within the province of the art historian although traditionally Art History in educational institutions has concentrated on painting, sculpture and architecture, a trio that goes back to the Renaissance writer Vasari. Similarly there is no one identifiable Art History. Approaches to the documentation, analysis and evaluation of visual material as with that of any other form of human production – music, literature, politics, agriculture – can be very disparate.

At one extreme there is a mode of inquiry that has as its premise a view of cultural history or communications in which the particular objects studied – paintings included – are examined as commodities within a system. The important thing here is to understand the system and how it works, not merely in terms of how it is organized but also in terms of the symbolic values it generates. Such an analysis is fundamentally concerned with power, with control and with economics. Thus, for instance, the art auction might be an object of study not for the individual items that are being sold there but for what we can learn about the transaction of values in Western society. Money is spent at auction but what is purchased has a value and a symbolic meaning

within a political economy which transcends the economic, monetary value. Why do people buy old things? What status do those acquisitions offer to them? What rules are followed, what rituals practised? And what social and class boundaries are crossed through the acquisition of objects? Art historians working on issues such as these – and they are as relevant to the study of Medieval patrons such as the Abbot of St Denis as to the anatomization of an auction at Sotheby's in 1986 – are closely allied to sociologists, economic historians and anthropologists.

At the other extreme, maintaining the traditional concerns of the discipline, are art historians for whom the object itself is of prime importance. For them the issue of quality is, therefore, a significant one. Here the aesthetic experience is an important starting point though tracing the history of the object and thus establishing its authenticity is equally necessary. It might be a painting, a bronze model, a drawing or any other artefact. As this form of inquiry is essentially object-based the art auction provides the *means* to an analysis of individual items. It is not of interest as a phenomenon in itself. Thus an art historian practising in this particular way would locate in an auction or with a dealer a work which may have been 'lost', may have disappeared from public view for several generations. Supposing it was, say, a painting by Rubens it would be possible then to slot this into the pattern of Rubens's life-time's work (his *oeuvre* as it would probably be called by art historians) like a missing piece into a jig-saw puzzle. Filling in the gap might change how the surrounding bits look or it might raise questions about bits that looked alright before.

There is much overlap and interrelated activity among different art-historical practices and the examples I have given are intended only to suggest different types of engagement. The discussion that goes on between different areas is itself a part of the attempt to define and redefine ways of dealing with visual communication. The traditional art historian's concern with quality, the implicit belief that some things are better than others, is challenged by those art historians whose concern lies more in the area of sociology. They would, very reasonably, demand who decides whether something is good or not and on what criteria are such judgements based. Is it simply the subjective judgement of one person or is it the accumulative judgement of society over a long period of time and if so, what section of society participates, how is the judgement manifest and to what use is it put?

Authenticity is an issue which, at a general level, distinguishes Art History from comparable disciplines like English Literature. Certainly some poems are anonymous, particularly works from earlier periods, but by and large we know who wrote what which is more than can be said for many visual works of art. When Giselbertus signed his name on the portal of the great cathedral of Autun in France under the marvellous carvings executed there in the twelfth century, this was a most unusual act, a turning point in the History of Art.

As a result of workshop practice (from the Renaissance to the nineteenth century Western artists worked in groups around a master) it is often difficult to distinguish who did what. Even when, in more recent times, the status of artists and sculptors became more elevated and they were gradually regarded less as artisans and more as specially gifted and respected members of society, many artists have preferred not to sign their works. Sometimes, for legitimate as well as dishonest reasons, later generations have added signatures to works of art which can be very misleading.

It is certainly true that students of English Literature will at some stage confront bibliographical problems: the mistakes made by printers, the variations on a single line which appear in manuscripts left by a poet, the emendations of editors through the ages, the piecing together of incomplete documents, and so on. But this is a highly specialized procedure and most teaching of English at sixth-form and undergraduate level assumes a permanent body of literature by known authors which can be read and enjoyed and discussed. The question of authenticity is, however, of major importance to the art historian and necessitates modes of inquiry that barely impinge on the discipline of English literature.

It is because traditionally one of the characteristics of the visual work of art has been its uniqueness that art historians are sometimes as much preoccupied with locating and authenticating as with interpreting. It is mainly in connection with painting and sculpture that the technology of Art History plays an important role. The examination of paintings through infra-red photography, the process known as dendrochronology through which the age of a wood panel can be assessed by counting the rings on the wood and many other scientific processes are used in the search to identify and accurately date works of art.

The uniqueness of many works of visual art is something which is often seen, therefore, as setting Art History apart from its fellow and interdependent disciplines. The student of English may feel a thrill of excitement on first reading *King Lear* and may be moved to go and read Shakespeare's other plays just as the student of History of Art who is stirred by the sight of Titian's *Bacchus and Ariadne* may seek out other paintings by the same artist. The student of English may not immediately and conveniently be able to attend a performance of *King Lear* but the text of this and Shakespeare's other plays will be readily and cheaply available to him on almost any bookstall. If our interest is with the experience of paint applied to canvas, photography can provide at best a very inadequate substitute. It is likely that other works by Titian, or whichever artist the student wishes to pursue, will be scattered in collections throughout the world. The loss and destruction of works of art in national and private collections – whether through fire, theft or malicious attack – is a constant sad reminder to us that nothing can replace the original. Shakespeare's *Macbeth* will never be lost but Poussin's *Golden Calf* in the National Gallery can all too easily be destroyed.

It is possible to regard engravings and photographic art works, of which there are or can be normally more than one copy, as unique objects each with its own history. Handling an engraving or photograph and seeing on it the marks of its production is, after all, quite different from looking at a reproduction. The preservation of engravings and photographs in museums recognizes this fact. However, we must also recognize that now, and at all times in the past, artists and public have encountered works of art primarily through copies or reproductions rather than through an original. The 'portrait' of Socrates that was known throughout the Ancient World and from which the philosopher has been known ever since is a copy after an original executed hundreds of years after his death. The art of Renaissance Italy was known to northern artists and craftsmen first and foremost through engraving. Since the development of photography and cheap printing methods it is very usual for us to encounter an original only after having become very familiar with its photographic reproduction. For art historians then, the dissemination of imagery through mass reproduction, its transformations and transmutations are as important as paying attention to the original. One might well ask which is more 'real', the *Mona Lisa* behind bullet proof glass in

the Louvre or the plastic-gilt framed reproduction selling in the rue de Rivoli outside?

Knowledge about works of art is constantly being updated, revised and reconsidered. The latest attribution is not necessarily the correct one and it would be too much to expect someone starting out as an art historian to be fully cognisant with all the articles on 'a recently discovered . . .' or 'a newly attributed . . .' in the specialist Art History journals. The beginner with a fresh and enthusiastic vision need not be daunted by exposition – indeed, it is necessary to learn the circumstances which led to critical works. Crowe and Cavalcaselle's massive book on the Italian Renaissance may appear definitive but it is important to realize that it was written at a time when incomplete information was available and it is, therefore, less than completely factually reliable, even though we may admire it as a pioneer work and as a piece of art criticism. Similarly we may read Roger Fry on Cézanne because he writes beautifully and has marvellous insights into what Cézanne was trying to do. At the same time we need to ask ourselves, in view of the fact that his book was written in 1927, whether Fry might not have revised his view had he been aware of some of the paintings and drawings of Cézanne which were then unknown.

In other contexts art historians might well be avidly reading Crowe and Cavalcaselle and Roger Fry, at the same time trying to locate their descendants and read their manuscripts, diaries and letters in the hope of discovering more about how these connoisseurs and writers worked. One branch of Art History is concerned with changes in Taste and in the history of Art History itself. How these earlier art historians worked, what methods they evolved, on what bases they made their judgements is of profound interest, therefore, to the art historian.

Historiography is the name given to the history of history, in this case it is the history of Art History, how the history of art has been constructed and written up by art historians from ancient Greece and Rome onwards and how ideas and methods have been formulated. A historiographer looks at a text not for what it tells us about particular artists, their lives and their works, but in order to recognize and analyse the historical and theoretical premises on which the writer based his or her discussion. Many of the assumptions upon which current expositions of the history of art are based derive from celebrated texts written and published in the eighteenth century or earlier. A concern with historiography

is more than the kind of concern with artists' writings as an extension of their art (Constable's lectures, for example) or as a theoretical means of understanding their art or the art of their time (Reynolds's *Discourses* or Diderot's Salon critiques, for example) that is often termed Art Theory in course material. Unlike Art Theory, historiography examines the principles underlying the construction of the discipline and thus helps us to be more discerning about the kinds of arguments being martialled in support of any given body of material and enables us to recognize what sort of history is being written and why.

Because the discovery and authentication of works of art has played such an important part in Art History, and because the first writers of Art History sought to demonstrate that the art of their time was more successful than that of previous ages, there has been a tendency for the art historian to be preoccupied with development and 'progress', with what one artist bequeaths to the next in the way of subject or style. Thus much art of the past has been seen in terms of one artist climbing, as it were, on to the back of his predecessor. This view of the art of the past (or indeed, that of the present) as a great chain in which A leads to B which leads to C, and so on, has its disadvantages. This sort of chain is often based implicitly, if not explicitly, on the assumption that as A leads to B leads to C (or Cimabue leads to Giotto and Giotto leads to Masaccio), art in some way gets 'better'. Moreover, there are artists who do not contribute to an easily recognizable development of this kind and who, therefore, get left out. Botticelli did not fit into the developmental principle devised by the Renaissance historian Vasari, and consequently his work was neglected and almost totally unknown to generation after generation until he was 'rediscovered' in the nineteenth century.

Art History has concentrated on great and acknowledged (mainly male) masters of the past. Certainly it is useful, and indeed it is essential, for us to know as much as possible about artists who have produced large quantities of innovative and outstanding works, like Michelangelo or Delacroix, but the disadvantage of the great master approach is that it tends to isolate the artist from the context of ideas, beliefs, events and conditions within which he lived and worked as well as from the company of other artists. It may well be that in some instances the identity of a group may be obscured by the treatment of an individual. Thus an overall view in which the artist is seen relative to his period is

the price that is sometimes paid for detailed documentation about his work.

How we choose to approach the art of the past must depend on the ideas of the age in which we ourselves live. There is, therefore, a constant and continuing debate about what we, as art historians, ought to be doing. Partly as a result of work in other disciplines in the Humanities and under the influence of French critical theory, art historians have begun to question the supremacy of the notion of authorship in the study of works of art and to challenge the assumed objectivity of the observer. The importance of the group rather than the individual is being recognized and the part played by the viewer is being examined in the social as well as in the psychological sense. The psychology of perception – how we see and how we codify what we see into meanings – has been an acknowledged area of inquiry for the past twenty years and more. But recently, partly in response to interventions from feminists, anthropologists and those concerned with psychoanalysis the idea of a neutral universal viewer has been challenged and questions have been posed about how the viewer is constituted in terms of class, gender and sexual orientation. Is *the* viewer assumed to be male, heterosexual and middle class? How, for instance, does a working class woman or a gay man relate to a nude by Ingres?

The impact of Marxist historical analysis on Art History has also been of major importance in bringing about changes in priorities in art historical practice. Many art historians who have never read Marx and who certainly would not describe themselves as Marxists have, whether consciously and deliberately or not, taken class, labour and the economic structures of capitalist society into account as determinants in the production of art whether it be in the Renaissance or in the present day. On the one hand popular traditions, 'low art' forms and mass communication have begun to receive serious attention from art historians. On the other hand more attention has been paid to the reception of artworks in their own day and to studying how a visual image can provide a ground for the making of meanings within a given society, meanings which may or may not have anything to do with the apparent subject matter or narrative of the image. Thus, for instance, a *fête champetre* or a courtly picnic scene by a Venetian sixteenth-century painter or by the French eighteenth-century painter, Watteau, may be a rural idyll of upper class love

and pleasure but may, at one level, also re-present and therefore re-enforce the power relations between women and men and between different classes within the society which produced the image. The countryside is not neutral but carries with it, by implication, its absent counterpart, the presence of the city and the court.

Feminist Art History has brought to light hitherto neglected or unknown women artists and has encouraged debate about women's art practice in our own day. Do women get a fair share of exhibition time and space? Do they get serious treatment from critics? Are there areas of human experience that are peculiar to women and which justify a separatist approach to the production and display of art? It is no longer possible to view Mary Cassatt as an appendage to her friend, Edgar Degas, or to see Artemesia Gentileschi as merely an arm of her father Orazio Gentileschi. Moreover, the analysis of images of women, whether in advertising or in paintings that are time-honoured and familiar landmarks in the canon, has been revolutionized by feminist discussion. Equally genres such as flower-painting and media like crafts and embroidery that have traditionally been the province of women now receive more sustained attention and a critical historical appraisal that places them in relation to other forms of artistic production. For feminist art historians the entire edifice of Art History is to be challenged, its assumptions, its methods, its objects of inquiry since all of these have been constructed within a patriarchal society.

Architectural historians are concerned with questions such as how the style of buildings changes, what the relationship is between the appearance of a building and its function, what part is played by sculpture and other decorative devices, how the final building evolved from its early plans, how the building relates to its environment, who built it and why, who paid for it, who used it, what it feels like as a three-dimensional work of art and many similar questions. Most architectural historians begin as art historians but, as with Design History, the discipline of Architectural History soon becomes very specialized with its own technical vocabulary and its own methodologies. Indeed, approaches to Architectural History are as various as those to Art History. Nevertheless the association between Architectural History and Art History is a firm and generally productive one. After all, buildings are the most universally experienced part of our en-

vironment although the destruction of fine buildings from the recent as well as from the remote past in every town and village is depressing evidence of our inability to notice and understand what is around us in time to halt the inexorable 'progress' of the developer. Many architects have also been painters and sculptors; it is unwise, for example, in studying Michelangelo's painting and sculpture to omit his activities as an architect. Moreover, architectural design, planning and the development of the environment necessitate consideration of power, politics, government, patronage and ways of living and working that also have far-reaching implications for art historians and other historians.

The great house or planned public building with its combination of architecture, landscape and decorative art (as well as the paintings hung in its rooms) has frequently been the total expression of a single philosophical, political and aesthetic point of view. For example, a house like Chiswick House near London attracts the architectural historian and the art historian. The paintings, sculpture and interior detail in this house might be the subject of individual study by art historians and the structure of the house might command the attention of the architectural historian. Landscape gardening is a subject of special interest to the student of the eighteenth century and the grounds of Chiswick would, therefore, be considered as visual works of art on their own merit. If we approach the study of a great house with this largeness of vision, there is a chance that we shall see 'parts answering part . . . slide into a whole', as the poet Alexander Pope expressed it when writing his epistle 'On the Use of Riches' to his patron, the architect and owner of the house, the Earl of Burlington.

On the other hand, a house and its estate may be the result of diverse building and collecting activities by different owners at different times in the past. If so, it will demand a slightly different approach if we are to ascertain what was created when. But the point about studying the house and all that goes with it in its totality still remains. When we look at the complex growth of an estate, whether it be within one man's lifetime or over many generations, we are considering questions of patronage: which artists, architects, gardeners were chosen, what they made, how much they were paid, where the money to pay them came from, how they were paid, and so on. By piecing together all the available information we may, with tenacity and inspiration, gain some picture of that elusive aspect of history which we call 'taste'

and at the same time discover important truths about social structures in the past.

The same principle applies in the study of, say, a new town development of the sixties or a garden city of the fifties and in the study of ecclesiastical buildings, the appearance of which is subject to constant change according to shifts in theological thinking, developments in techniques of building and the vicissitudes of government and governing policy. Take, for example, the Church of Gesù Nuovo in Naples which, built between 1584 and 1601, on to the façade of a Renaissance palace, contains a rich treasure of frescos and ecclesiastical objects and which has an interesting political, theological and social history. In order to appreciate fully all this, the building must be studied as though it were a living organism. In the case of the new town, use, wear and tear, ownership and social mobility would all need to be taken into account.

It is in the study of taste and patronage that the art historian and the social historian most frequently come into contact. One of the art historian's most difficult tasks is to account for the popularity of certain subjects, styles and artists at certain periods in history. To achieve this both reliable factual data and an ability to interpret imaginative acts of communication are needed. One might, in fact, very well argue that the distinction between the historian and the art historian is a false one. But the historian is not a drudge and the art historian not an aesthete who depends on the historian to make the discipline of Art History academically respectable. Art historians need to do their own research and, whilst the two disciplines are complementary, they are not interdependent. Historians can learn much about art practices, conventions of image making, communication and ideology from Art History; at the same time Art History has to do more than simply see history as a background to art.

The acts (or artworks) we have been discussing may be used as evidence by historians though this, as we shall see, creates its own problems. But art historians, as we discovered right at the beginning of this chapter, cannot just be art appreciators; they have to be in a position to unravel and evaluate the meaning of a work of art in its historical context. Only by doing their own historical research can art historians begin to understand how a painting looked to people who saw it at the time it was painted or to the patron who commissioned it.

The historian of taste also faces the problem of working in several media. The great private patrons of the past, those who were responsible for commissioning so many of the great paintings that now hang on the walls of our national galleries (thanks to wars, revolutions and economic difficulties in Europe), bestowed their beneficence and their orders not only on painters but also on musicians and poets.

We have been talking as though the historian of taste is solely concerned with aristocratic patrons like the Habsburgs or the Hamiltons. Mass culture and the visual arts is an appropriate area of study for the art historian. This is evident when we look at the development of cheap methods of reproduction (like lithography) or when we examine the response of the public to works of art after the inauguration of regular open exhibitions in the nineteenth century or the way in which the poster became such an important medium for artists in Germany in the 1930s. Any study of patronage involves the principle of supply and demand; art historians who engage in this sort of inquiry may therefore find themselves as much occupied with finance as with fine art.

There exists no single line of inquiry that we can label Art History. This much will have become evident. Indeed, the reader may well feel that we have evaded the basic question: what is art? Part of the purpose of this book is to show that there is no single answer to that temptingly simple question. The fact is that once we apply ourselves to the question of what art is we become philosophers rather than art historians. Philosophy, and particularly that branch of Philosophy which deals with aesthetics, has made a contribution to the discipline of Art History. The art historian's role has always been, however, to elucidate the work of art, not least contemporary art, relating it to its social-historical context rather than raising it out of time and defining it or 'appreciating' it as the disembodied work of genius.

Nevertheless, the question of what is a legitimate line of inquiry remains a contentious one and it is a sign of health that such questions should be asked. If design historians are discussing the evolution of the characteristically shaped and packaged food-mixer or beer-can, what should be the range of art historians? Should they confine themselves to architecture (in which case should everything from monasteries to cooling towers be included?), easel paintings, sculpture, fresco and the decorative arts like tapestries and ceramics? Or should they use their exper-

tise upon other sorts of visual communication: advertisements,
film, Tretchikov and mass produced artworks, clothing and the
more ephemeral aspects of our visual experience like sports events
or those in the creation of which no individual or group seems to
have had control, like the cityscape we see around us every day.
Part of the answer lies, as has been indicated earlier in this chapter,
in whether or not quality is an issue at stake. But even if art
historians agree, say, that it is recognized French painting that is
the object of study (say that which has, through whatever means,
withstood the so-called test of time) they may still disagree about
whether these paintings should be viewed as discursive (telling us
things, conveying ideas) or sensuous (expressing feeling and
transmitting materiality).

One manifestation of the re-evaluation of Art History as a
discipline is the ever-widening range of material which the art
historian is expected to discuss and interpret. Another is the lively
debate about how this material ought to be used by art historians
and also by those specializing in other disciplines like sociology,
psychology and history and anthropology. Generally speaking it
is true to say that many traditional barriers between disciplines
have been broken in recent years, generally to the benefit of both
sides. We used to be familiar with an image of the art historian as
a member of an aristocratic élite, living on a private income
surrounded by priceless works of art and occasionally contribut-
ing articles of a learned nature to one of those monthly journals
which might to the uninitiated appear to exist mainly for the
benefit of those who buy and sell art, so crammed are their pages
with advertisements. Perhaps because of the destruction of these
traditional divisions, this old-fashioned image of the art historian
now scarcely applies and the discipline has gained immense
strength from those who have entered it from many varied fields
of activity.

From psychologists we have learned, through the valuable
mediating contribution of scholars like Sir Ernst Gombrich, how
to understand more of the processes that make up what we call
perception; in other words, how we see things and what part our
seeing and learning and knowing plays in the making and reading
of pictorial images. With the help of psychology, archaeology and
chemistry, it is possible for us to begin to know a little more about

what colour has meant in our attempts to communicate pictorially through the ages.

Some art historians have turned to Freudian and post-Freudian ✓ psychoanalytical techniques in an attempt to reach a greater degree of understanding of the meanings of works of art and how we 'read' them. Whilst there are obvious dangers in imagining that an artist long dead can be, as it were, resurrected for the analyst's couch, works of art themselves supported by reliable biographical data can be recognized as having latent as well as manifest meanings. Scenes of beheading (for instance John the Baptist) may thus be interpreted, using Freud's case histories, as narratives of castration. Representations of women may be analysed according to theories of fetishization. Such a method, critics may object, is transhistorical – it applies a theory devised in late nineteenth-century Vienna to a body of material produced in a different time and place and interpreted by a scholar in yet a third time and place. It also treats the individual rather than society. The proponents of this method would probably argue that they take environment into account and that Freud's theory, as opposed to his clinical practice, has a wide relevance to the human condition and therefore to human image-making. Moreover they would posit a social/political subconscious with the individual and the group inextricably linked. Recently the work of the French psychoanalyst <u>Lacan</u> has been drawn upon by scholars interested in the construction of identity and the role of the gaze (looking) as a crucial part in this process. The analysis of visual pleasure using theories derived from ✓ psychoanalysts' examination of desire in the unconscious was initiated in film studies and has spread to other art forms.

Psychologists have helped to demonstrate the superior power of the visual image over the written or verbal description in arousing immediate and strong responses. This goes some way towards explaining why the visual arts (especially painting) have always had an important propaganda value. Art as propaganda has always been as much the province of the social historian as the art historian but collaboration can be very productive. A portrait of a ruler may have been intended by its subject as a piece of propaganda but it is still the result of an imaginative act on the part of the artist. The art historian who ignores historical facts does so at his peril. Goya's painting, *An Episode of 3 May 1808: The Execution of Rebels in Madrid* demands to be read within the historical event which provoked the picture and which is cited in

the title. Equally, however, it would be rash of the historian to regard this painting as an 'illustration' of what happened on 3 May 1808, or even of what one individual, the artist, saw that day in Madrid.

Pictorial documents are very seductive; they can so easily enliven the historian's text. How dangerous it is, however, for the historian to assume that pictures from a given period can provide an authentic record of how life was lived or even details such as what people wore. We know, for example, that in the eighteenth century Gainsborough painted a number of sitters dressed in the seventeeth-century fancy 'Van Dyck' style clothes. It is thought that he kept a collection of such clothes in his studio for his fashionable sitters to pose in although he usually preferred them to wear their own clothes. Dutch seventeenth-century paintings of everyday life (genre scenes we call them) are often thought to record faithfully how people lived at that time. But we now know that Jan Steen's *School for Boys and Girls* (National Gallery of Scotland) is an allegory of the school of life in which different parts of the painting represent different human vices or virtues. It may also bear some resemblance to the appearance of a Dutch schoolroom in the seventeenth century but, since the intention of the artist was not to provide a mirror image of what he observed but a commentary on life, it would perhaps be dangerous to assume this to be the case. Even with what we might regard as documentary reportage we find convention at work. In photography, and in realist art the reality effect is the result of a carefully produced organization. It has been demonstrated, for instance, that a journal like the *Illustrated London News* which presented itself as documentary in fact used and re-used the same engraving, introducing rioting crowds or a royal procession into a standard urban background as the current situation demanded.

Paintings can provide factual information of the sort the historian is seeking. Joseph Wright of Derby depicted in great detail an eighteenth-century air pump in his painting *An Experiment with an Air Pump* now in the Tate Gallery. But in using the contents of paintings like this as historical evidence, we must employ much discretion and caution, checking all other known verbal and visual images of a similar kind and making sure that we understand as far as possible the intellectual and imaginative climate within which the artist worked as well as the historical background of events.

The same painting might be analysed by an art historian using a method associated with French structuralism, seeking to identify the deep structures within a work independent of its apparent narration. The components of the picture are thus seen as signs; they carry meanings which may be independent from or even in contradiction with the apparent subject of the painting. In this particular work there are ten figures but in not one case are both eyes visible to the spectator. A discussion of this characteristic, possibly relating it to hands and spherical containers might lead to a discussion of this painting whose subject matter is science and history as a discourse on sight and blindness. Semiology (the science of signs) is at a more highly developed stage in relation to language-based art forms than in Art History but it is, nevertheless, a theory and a practice that has already made an impact in the study of paintings and is widely encountered in film and media studies.

There are many close ties between Art History and Literary History too. The friendships that are known to have existed between artists, writers and musicians (Cézanne and Zola, Reynolds and Johnson, Titian and Ariosto, Delacroix and Chopin) should have ensured that art historians are keenly aware of what each discipline has to offer. There are also the poet-painters or painter-poets like William Blake whose work demands to be considered as a whole. The study of paintings which treat subjects from literature and, connected with this, the field of book illustration, can be extremely rewarding for Art History especially if one literary text is followed through a variety of pictorial interpretations. It would be interesting to trace, for example, narrative cycles based on Ariosto's stories in the Renaissance period in Italy or paintings which derive from a reading of Malory's *Morte d'Arthur* in England in the nineteenth century. But questions such as 'how can the artist transfer to the static medium of paint a story which is expressed through a time sequence in literature' require a theoretical basis for exploration. A clear understanding of the characteristics and limitations of different media – of linguistics, line and colour – and an awareness of the functions of painting and literature are essential for this kind of work.

Reading is, like looking, historically located. Art historians have begun to ask questions about the relationship between words introduced into pictures (as in Medieval manuscript illuminations or the collages of Braque and Picasso where pieces of

newsprint become part of the image) and the spoken as opposed to the written word. The shifts and associations, differences and complementary characteristics between written and spoken and between written and imaged depend on a complex set of historical conditions at any given moment in time. Recovering these relationships may lead to a radical reappraisal of the meanings born by a given image.

From what we have said in this chapter it will have become evident that there is no single route and no single object for the art historian. The skills that are needed are many but so are the intellectual rewards. Like any other discipline (the word is apt) Art History demands commitment, dedication and lots of hard work: looking, reading, asking, searching. Once you start you seldom want to stop. The following chapters are intended to help those who have made a start to proceed on their way.

? Theology –

3
How Art Historians Work

An art historian is a person who is engaged in exploring and discussing the nature, the effectiveness and functioning or the history of art and artefacts. As a profession, art historians tend to group themselves into those who work in museums and art galleries and those who teach the subject. The division is unfortunate and misleading. It is essential for keepers of art galleries to understand about the conservation and insurance of works of art in their care. They are also responsible for researching and cataloguing their collections, providing a public service by organizing exhibitions, answering inquiries and other similar activities that are not normally part of the working lives of teaching art historians. On the other hand, those who teach the subject may find themselves preoccupied with problems of communication, with syllabuses, library facilities, equipment for projection of slides and examination papers. There is a widespread notion that art historians in museums are interested only in objects and their material state and that academic art historians are interested only in ideas. There is perhaps some particle of truth here but nevertheless the discipline to which the keeper of a museum or gallery and the teacher of Art History adhere is fundamentally the same and their work is interdependent.

History of Art students can expect to do at least some of their learning supervised or unsupervised in art galleries and museums. The directors and keepers of art galleries are usually generous in allowing small classes to take place in front of pictures. Some even offer special provisions for parties; the Tate Gallery, for example, provides stools to enable groups to sit while they study a painting. Many galleries and museums in London and in the provinces have print rooms containing valuable collections of engravings which

are extremely useful direct material for study and teaching. Some educational establishments enjoy very successful liaisons with their local galleries and museums, enabling students to work there voluntarily in their spare time, gaining experience in cataloguing and other aspects of gallery work.

The writing of the history of art is the shared responsibility of all art historians. The research and documentation of paintings and other objects, the composition of catalogues whether for special exhibitions or for permanent collections, these provide the foundations upon which art-historical research, writing and ultimately teaching is built. Whilst art historians may, in some cases, concentrate on interpretation or reception rather than documentation, most art-historical work is to some degree or other dependent upon an empirical base.

A specialist in another discipline, somebody who asks questions and searches for answers quite independently of any job or organization, or most significantly a practising artist may also be engaged in art-historical activity. The architectural historian needs to learn from the construction engineer or the bricklayer or welder the properties of different materials if he or she is going to look at the man-made environment as a totality, considering where it is, who uses it, what is to be expected in the future, rather than simply viewing it as an object or series of objects to be looked at. Similarly the art historian must ask the artist about colour and materials whether it is ancient works of art or contemporary productions that are being addressed, bearing in mind that there is a history of pigment to be taken into account. The analysis of the pigments of old paintings is a highly specialized activity conducted in laboratory conditions and requiring considerable knowledge of chemistry but art historians cannot afford to ignore in general the actual process of making the work of art.

Frequently the only way is to try out the materials. If it is a question of why polystyrene sculpture has immediately recognizable characteristics, it is necessary to try working with that material. Similarly, there is no better way of appreciating the qualities of watercolour as a medium than actually painting with it. The purpose of the art historian in these enterprises will differ from that of the artist because the primary concern will be not with creating art but with observing the behaviour of the materials from which the artwork is made.

The principle of learning from the artist applies not only to

materials but also in some cases to subject-matter. In painting, for example, the particular problems (whether visual or practical) that the artist experiences may sometimes be best understood by the art historian who is prepared humbly to put herself or himself in the artist's place. If the subject under discussion is Rembrandt's or Bonnard's depictions of children, the art historian will find it helpful to spend some time actually trying to draw children because only then is it possible to appreciate that children never stay still for more than a minute except when they are asleep (notice how many artists have drawn children asleep!) and that the proportions of a child's body in relation to its head are quite different from those of an adult. We may know this to be a fact, having read it in a book, it is only by trying to draw a child that we realise it.

If we are interested in the still-life paintings of Chardin or Matisse, it is well worthwhile ourselves trying to isolate or assemble a group of objects for a still-life, moving round it, looking closely at it, working out how many different ways we might see it or how we could express our knowledge of the objects involved. A child, asked to draw a group of objects, looks at each one separately and draws each one independently. We may think that we are more advanced than this but it is surprisingly difficult to see and understand the relationship of function, shape, size, colour, texture of a group of disparate objects.

There is no prescribed method for all art historians as will have become clear from earlier chapters in this book. As with other disciplines, how the art historian works depends very much upon the nature of the material addressed and the questions posed as well as the method adopted. What we can do is to describe the resources most commonly used by art historians and indicate the processes of research through which many art historians will go on their way to communicating to us what we have come to know as Art History. A diagram and a series of questions can help us with this discussion, though it cannot indicate the order in which the questions might be posed. My artwork, for the sake of clarity, is a painting, but it could be a piece of sculpture, an oriental vase or a group of objects or a combination of the natural and the man-made like Stonehenge or the Statue of Liberty. Or, indeed, it might be an event like the foundation of a national museum or a policy like that of the Arts Council in any given year. Clearly the kinds of questions posed would vary according to the kind of

object or event under discussion. My questions are based on the assumption that we are dealing with a post-Medieval, Western painting; this is simply because these tend still to be the kinds of objects students most commonly encounter in Art History courses.

The painting as physical object

One of the first questions the art historian has to ask himself is 'what am I looking at?'. This may seem to be stating the obvious but it is surprisingly easy to forget that a luminous 35 mm Kodachrome colour slide or a shiny black and white photograph is not the original work of art. Clearly we cannot normally take an Indian miniature or a Van Gogh home with us and we must take advantage of modern techniques of reproduction but we should also be aware of the dangers inherent in using these materials.

Most art historians use photographs, even when the original work of art is at hand. Photographs are necessary for comparative purposes. We may want to compare our picture with others by the same artist or similar works by other artists and the only way we can do this, unless we happen to have access to a big exhibition, where we can see all the known works of the artist and lots of comparative paintings hung side by side (though remember even then that someone has chosen them to demonstrate his or her particular view of the artist – it will not be the only one), is to take along our photographs and hold them up alongside the painting. Nearly all art galleries and museums provide a photographic service. In addition there are many commercial photographers who specialize in fine art photography. Many art historians find it worthwhile, however, to acquire at least some basic expertise in photography. It sometimes happens that art historians find themselves trying to reconstruct the appearance of lost or destroyed works of art. In this case, photographs, engravings and any other sort of reproduction have a very special and important relevance to the study in hand.

For the twentieth century with its emphasis on technology, the definition of a work of art is an extraordinarily complicated matter. We can no longer talk in simple terms about 'originals' and 'reproductions' since many artists are themselves using those

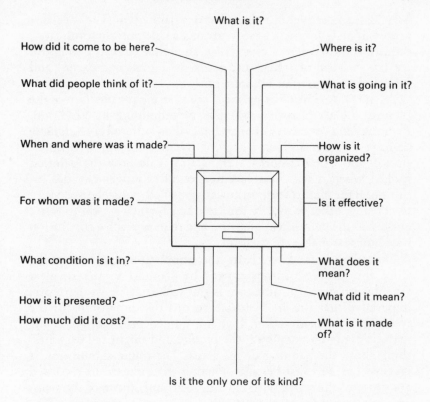

very methods of reproduction in their work. For this and for other reasons some scholars avoid the use of the term 'work of art' altogether.

The materials from which a work of art is made are called the medium. It may seem a simple enough matter to decide what the medium of a picture is. In fact, questions of technique can be very complicated. Those concerned with conservation and restoration need a very detailed knowledge of materials and how they behave under certain conditions. What happens to medieval altar-pieces painted on wood when they are exposed to damp or heat and what happens to a contemporary work of art in mixed media (wood, polystyrene, old rags, wire netting and paint, for example) with the passage of time are questions for the professional restorer. However, every art historian, student, teacher and researcher should be able to recognize the medium of the work of art. This includes not only the type of paint (oil, watercolour or gouache,

acrylic, for example) but also what it is painted on. The specialist art historian working in a more advanced field may, in some cases, require a knowledge of chemistry, an ability to read a technical treatise in Latin or Italian and access to a good microscope and infra-red photographic equipment.

At the same time as he or she is considering the medium of the picture, the art historian will also be examining its condition. Paintings and other works of art have often suffered considerable damage through accident, neglect, overpainting or well-intentioned but brutal cleaning. Trying to decide how the painting looked when it was first executed requires judgement and intuition. If the picture in question is unfinished, it may be necessary to consider other works by the same artist which appear to relate closely to the painting in question and then to reach a conclusion based on reasonable speculation.

Photographs tend to create the impression that everything from the most enormous canvas by Rothko to the smallest seventeenth-century miniature is the same size. It is, therefore, imperative that the art historian record the dimensions of the work under consideration. If it is a framed painting, the frame may be contemporary with the picture and might tell us something about the painting or the artist. The frame should not be ignored but we must be clear whether the dimensions recorded are those of the work with or without frame, those of the paint area or those of the total canvas.

As for the frame, it sometimes happens that the artist himself has designed and made the frame to reflect and reinforce the statement of the painting. The pre-Raphaelite artist William Holman Hunt arranged for the frames of many of his pictures to bear texts and emblematic designs which help the viewer to interpret the meaning of the picture. Even when we are dealing with an unframed contemporary painting, the closest scrutiny of the borders and edges is necessary in order to discover where and how the paint surface terminates.

In art galleries and sale catalogues we frequently come across the words 'attributed to' or 'school of' preceding the name of the artist. Providing answers to the questions 'who painted the picture?' and 'when was it painted?' is probably the oldest and the most traditional occupation of the art historian. At one time, art historians made attributions exclusively on grounds of style. It might be said, for example, that a drawing could not possibly be

the work of Rubens because in all the other known Rubens drawings the feet of all the figures had enlarged big toes, or that a painting must be the work of Tintoretto because the trees were painted in the same manner as in all the other known pictures by this artist.

Today, with the wider application in all branches of the humanities of technology and the increased emphasis on the history in Art History, the pure study of style tends to be given less prominence. Everyone should be able to learn to see and recognize but there has been in the past a tendency to surround the skill of looking and knowing with mystique. The important thing is not only to see but also to understand. A friend of mine once likened the connoisseur to an expert train-spotter who did not know how a steam engine worked, who the driver or passengers were or, indeed, where the trains came from or where they were going.

Stylistic analysis can blind a viewer to the broader understanding of a painting and can result in a failure to recognize the variety and complexity of expression and meaning within the work of any one artist. Nevertheless, we should still be ready to recognize the intuitive ability of the connoisseur, the person who has spent years becoming familiar with the characteristic and subtle differences between one artist's method of execution and another's and who is able to make an attribution by eye alone. Not a few works of art have been rescued from oblivion and even from the bonfire by the timely exercise of a connoisseur's skill.

Assuming we are able to say who executed our painting, the next question is 'when?'. If the artist's studio or logbook survives, or if the painting was exhibited during the artist's lifetime, we may be able to say fairly definitely when it was painted. Otherwise we have to rely on whatever details concerning the artist's life are available in biographies, letters or critiques, printed or in manuscript. Comparing our picture with all known and dated works by the same artist (taking into account style, subject and technique) may also help us to decide when it was painted.

Our picture may be anonymous or it may be associated with a group of painters rather than with an individual. In this case, the question 'where?' is as important as the question 'when?'. If it can be shown that the picture was painted in a particular place at a particular time (maybe it is inscribed 'Roma, 1790' or 'Munich, 1930') and all the other evidence of subject, style and technique

points to a master working in that particular place at that particu-
lar time, the argument may be strong enough for us to use that
label 'attributed to'.

As a document, the painting may not only provide us with
information about the overall development of the artist but it may
also tell us about the age in which it was painted. The critical
response to a work of art is part of its history and, therefore, we
want to know how the painting was received by those who saw it
at the time it was executed and how it has been regarded by people
ever since. The wider the range of opinion we consult the better:
the patron, the critic, other artists, friends, relatives. Perhaps it
was painted in an age from which few records have survived.
Nevertheless, by reconstructing the circumstances and the social
milieu in which it was created, the painting can be of inestimable
value and interest as a document and, most important, we can
begin to understand how beliefs and attitudes are not merely
reflected in pictures but are constructed and disseminated in
imagery.

The painting as image

If our painting is figurative, that is to say, it re-presents something
we recognize from the world around us, our discussion may
concentrate on what the various parts of the painting seem to
convey via this imagery. An image in this context is a painterly
sign that corresponds to something we recognize or have an idea
about. A group of images – say, houses, colonnades, a child, a dog
– constitute an original visual language when placed side by side
or in combination. Discussion of the painting as image may refer
to this as the field of vision to distinguish it from a frame of
reference outside of the painting. Discussion of the painting as
image is a way of deconstructing these signs in order more fully to
comprehend the idea or ideas expressed. Understanding how and
why they function as they do is as important as locating any given
meanings. In other words, examining the painting as image is
studying how ideas are encoded.

Dutch seventeeth-century paintings have long been enjoyed
and admired for the apparently clear and precise way they allow
us to enter into the domestic world of Holland in the seventeenth
century. Such pictures can be taken as stories in paint. The girl

with the beautiful profile who reads a letter – who is it from? A serene middle-aged woman is washing dishes in a back kitchen while through the door we see a tempting vista along paved passage-ways into cool interiors or airy courtyards inviting us into the world of picture. At the same time, we may, without being very consciously aware of the world that the artist is describing, find ourselves immersed in contemplation of the fold of a dress, the gleam of polished tile juxtaposed with the rough texture of earthenware, or the way in which the artist has used various shades of red and gold in different parts of his painting. These qualities are in no way disconnected from the 'story' of the painting. Indeed, the 'story' is told through them but it is sometimes enriching to appreciate the making of the image without deliberate reference to its meaning. In that way we can concentrate our attention and reduce distractions.

There is, however, another equally important aspect to the painting as image. This is what we might call 'the obscured meanings' although we have to remember in using this term that these meanings were possibly the most obvious ones to people looking at the painting at the time it was executed and have only become obscured with the passage of time and changes in the visual vocabulary of art. Paintings are not puzzles to be solved and in a sense nothing is 'hidden' because the evidence is always there. However, we may not notice or be aware of the importance of an image or a group of images until someone has pointed it out.

To continue with our previous example, many of the Dutch paintings to which we have already referred, are, it is now realized, far more than mere mirror reflections of everyday life in seventeenth-century Holland. They may, or they may not be that – some very strict comparisons have to be made before even that point is convincing, since we have no photographic record and not a great deal of reliable documentary evidence about what Dutch seventeenth-century interiors actually looked like. But in any case, if we compare the images in some of these pictures with the appearance of objects or groups of objects in contemporary literary works, we find that they have very particular meanings.

A mirror may be depicted in a room because the artist actually saw it there. We cannot be sure about this unless he has left a precise account of how he painted the picture or someone else who knew him well and saw him painting has left a record. Equally he may have introduced a mirror into the room because

he wanted to show us what was at the other end of the room, or
he wanted to show us an alternative view of a figure, or because he
enjoyed the variation in colour values offered by the objects in the
room reflected in glass, or because he was interested in a virtuoso
display of his own dexterity in being able to paint reverse images.

There may also be a further reason why the artist introduced a
mirror. In the seventeenth century a mirror was a sign of vanity,
a worldly attribute. We know that mirrors possessed meaning in
the period because whole books were published containing pre-
cise instructions about this sort of sign language and telling
writers and artists the meaning of certain images in conjunction
with others. So the presence of a mirror in the room may be an
important clue to how the subject of the painting should be
interpreted on a moral level.

If the painting we are discussing is a non-figurative work, that
is to say, an abstract work, then our approach will vary slightly.
We are still concerned with the way separate parts of the painting
work independently and as a whole but we are not looking for any
story to be told or explicit instructive meaning in the picture. This
is not to say that the picture does not convey ideas or that it is not
instructive. Simply, in an abstract painting the images are not
descriptive. They may convey to us qualities such as, perhaps,
brutal strength or determination of purpose or waywardness or
acquiescence. They may equally well, however, have no such
'meaningfulness' and operate in relation to the viewer purely
through a language of shape, line and colour. The very absence of
recognizable features from the familiar external world often
makes this experience all the more powerful.

Life is never simple, however, and many paintings are neither
wholly representational nor wholly abstract but are a combi-
nation of the two. At all events, what is most important is for us
to remain alert to what the image or the shape or the brush stroke
or the piece of paper stuck on to the canvas contributes to the
whole. To use a common expression, we need to decide how it
works. To do this we need also to have some method for
understanding how we respond over and above the simple 'I like'
or 'I don't like'. Aesthetics, the psychology of perception and
psychoanalysis may all help us with this though they will also in
all probability take us away from consideration of the painting as
object.

The painting as possession

The idea of the artist as an eccentric genius living in isolation in a garret and painting masterpieces which are not bought by anyone and, finally, dying of starvation or tuberculosis is, for the most part, far from the truth. Of course, there have been many artists who lived out their working lives totally unrecognized, there are those who suffered extreme poverty and there are those who preferred to isolate themselves from society. However, most artists painted pictures for people. Some artists commanded very high prices in their lifetimes and some, like Rubens, for example, led extraordinarily interesting lives in the midst of political intrigue, continental travel and court diplomacy.

The history of painting is not only the state of the canvas, what it means and all the other things we have talked of but also its physical history as a piece of property. As soon as we ask who it was painted for, we become involved in the question of patronage, finance and commerce. We need to know where the painting has been for all the years since it was executed, partly in order to be sure that it is the painting we think it is (this is especially true in the case of verifying lost works of art) and partly because one of the responsibilities of the art historian is to chart the history of taste and consumption.

Works of art represent capital investment as well as visual pleasure or nostalgic record. They are bought and sold, transported across continents, lost and found again. There are notable examples of paintings which have remained in the same place and have passed down from generation to generation. For the most part, however, tracing the original owner of a painting (he may have commissioned it or he may have chosen it from an exhibition or from the artist's atelier) involves determined detective work on the part of the art historian.

We may need to consult manuscripts such as the artist's account book, his letters, contemporary documents relating to his life. We may also turn to the putative owner and find our hypothesis confirmed by the discovery that he kept a record of the commission and the purchase which is still extant in a county record office or in his family's archives.

If the canvas has not been relined and is still in its original state (that is, without having been cut down in size), it may help to look at the back of the painting to see if there are labels from dealers or

exhibitions or inscriptions of any kind. Sale catalogues from
long-established dealers like Christie's or Agnew's, especially if
someone at the time of the sale bothered to make notes in the
margin, will furnish us, if we are lucky, with information about
the fortunes of our picture through the years. The prices that
pictures have fetched in the past indicate to us the relative
popularity of the artist or his work at any one time.

It is sometimes possible for researchers to consult dealers' stock
books to find out about owners and purchasers. Old exhibition
catalogues, wills and other legal documents as well as older
art-historical essays can be very informative, but great care is
needed in conducting these searches, for any one painting may
have been attributed to a dozen different artists in the space of a
hundred years. There were, for example, an astonishing number
of works by 'Raphael' and 'Mantegna' sold in London during the
last century.

It is not only the artist but also the titles of paintings that change
with time. People tend to give a painting in their possession the
sort of title which suggests how they feel about the picture.
Critics and writers often assist in this process of accretion. Thus,
for example, the picture which John Constable painted and
exhibited as *Landscape: Noon* is now known by everyone as *The
Hay Wain*. Such changes of title are inconvenient when one is
trying to trace a painting, but they can also be extremely instruc-
tive in so far as they point to the way in which people have
responded to the picture in the past. Clearly, the hay wain which
is crossing the pond in the foreground of Constable's picture, that
is, the narrative part of the picture, was what attracted people's
attention rather than the landscape which is a much larger part of
the canvas.

The artist may have painted the picture for herself or himself
without regard to any patron but it is usually the case that works
of art are, to some extent, the result of a relationship between the
artist and other people. It may be the general public for whom the
artist is deliberately painting, it may be a particular social or
political group, it may be the jury of some competitive enterprise
or it may be a private individual. In all cases the relationship of the
artist with his proposed audience is profoundly important both
for what it tells us of the period itself and for what it tells us of the
painting. It is, of course, very difficult for us to know who the
artist thought of as an audience and whether he or she even

thought of it at all. The medieval artist painting a mural in a church may have believed it to be his task to communicate with a great variety of people, most of them illiterate, with a range of capacity for response. He may, however, have thought of the clergy or God as his audience. Illiteracy itself may have ensured a value placed upon oral communication unknown in our own day. Thus the conditions of viewing anything in the Middle Ages must be not only taken into account but penetrated by historical inquiry.

If the artist is painting for a particular social or political group, his or her work may have elements of propaganda and we must be very sure that we understand what we are looking at. We can only adequately understand the profound revulsion expressed in the graphic work executed by the German expressionist artist Kaethe Kollwitz in terms of the audience she hoped to arouse in Germany in the 1930s.

In the eighteenth and nineteenth centuries when the academies had immense influence and prestige, many artists painted in a way that they knew would be favourably regarded by those judging their pictures and deciding whether they should be shown in what was virtually the only public exhibiton of the year. Individual critics like Diderot in France in the eighteenth century or Clement Greenberg in America in the twentieth might be said to have exerted a powerful influence on the way their generation strove to express ideas in visual form.

If the patron is a private individual, questions of human relationship as well as questions of finance will occupy us. Certainly there have been extraordinary cases of patrons who have simply bought up what the artist produced without discussion or question and have thus provided consistent and invaluable material support. The French colour merchant Père Tanguy, who acquired so many impressionist canvases in the second half of the last century in exchange for paint, often rescuing Pissarro and his friends from near-starvation, seems to have done exactly that. At the other extreme, however, are the insistent and demanding patrons with a clear idea of what they want and who will continue to nag until they get it. Patronage clearly carries for the artist both constraints and advantages. The art historian collects the evidence and endeavours to gain a true picture of the situation.

The History of Art embraces such an enormous range of different

aspects of our visual environment that it would be impossible to describe in one chapter how all art historians work. We have posed a series of questions about a hypothetical work of art in order to demonstrate some of the ways in which art historians work. The discussion has been limited because Art History in many of its facets challenges the very relationship between artist and object produced that is posited in much art-historical writing and which forms the basis of this exposition. To what extent, if at all, the artist's intentions are relevant to an art-historical inquiry is open to debate. For some it is the *how* of communication rather than the *what* that matters. Nevertheless, the kinds of procedures described here are those that are still commonly met with and, in one way or another, they underlie even the most provocative and innovative challenges to the discipline.

So it would now be helpful to remind ourselves that most Art History is not conducted with one object alone, though sometimes a case study of an individual work of art is worthwhile and helpful. Art is not created in a vacuum and most valuable art-historical studies are to a greater or lesser extent comparative. This does not mean necessarily that art historians are always comparing objects from different periods of time in order to demonstrate some kind of development; equally valuable may be a discussion that is based on theme or subject regardless of historical concurrence or chronological development. While one art historian might be concerned with a study of the development of Fernand Leger's art in the early years of this century, another might take the subject of one of his paintings, *The Card Players*, and consider what card players meant to Leger, what they meant to Cézanne and what they meant to the seventeenth-century French artist Matthieu Le Nain. Similarly, one art historian's work might be concerned with the methods used by Robert Motherwell, the present-day American painter, whilst his colleague's work might be on the significance through the ages of black paintings in the Western tradition.

Art historians often talk about movements. At worst, the term 'movement' in Art History is simply a lazy way of avoiding serious consideration of individual artists or of historical events. To say that Géricault was a part of 'the romantic movement' is to place him in the nineteenth century with an amorphous mass of artists, writers and musicians generally believed to have subscribed to a vague artistic philosophy based on individuality and

nature. This sort of art-historical Happy Families is not very helpful. On the other hand, the art historian is bound to ask questions about why and how one person, one group of people, one event or one work of art provokes reactions which might be classed as artistic, political or social but which will, in all probability, be all three. Here, the art historian will be exploring a 'movement'. Why cubism should have evolved at a particular moment in history is a question which exercises the art historian and necessitates considering, not merely one, or even a series of works of art but many events both national and individual and many artefacts, books, poems, paintings, sculpture.

The art historian who is interested in cubism as a visual and historical phenomenon will need to become immersed in the period of time when this thing happened. Anything and everything will be important: the day and even the hour when Picasso met Braque, the materials they bought, found, made and used, who their friends and acquaintances were, the places they visited and the books they read. It would be impossible to prescribe a single method for all art history. Each scholar has to formulate his or her own questions and find means of answering them according to the needs of the subject being researched.

The traditional methods of art-historical study derive from the accumulated cultural experience of the past. For a long time, art was regarded as something decorative or external to our lives, an object that was applied or introduced deliberately into everyday surroundings, beautifying them and improving them. The residue of this 'drawing-room' attitude undoubtedly remains with us. The art historian, like the scholar in any other discipline, has constantly to examine her or his own position in relation to the past and in relation to his or her own time. It is necessary to ask why this particular work of art has been selected for study in this particular way. An example may help to illustrate the point.

The art historian who chose to make a detailed examination of the carved capitals of the twelfth-century monastic church of St Benoît-sur-Loire, where imagery has close connections with contemporary biblical, theological and genealogical writing, would surely be missing much of the 'meaning' unless he or she seriously attempted to know the everyday, human events out of which the church was constructed, what went on inside it, in what way it manifest and was a part of power relations in church and state, what part ordinary people played in the building of the

church and what they contributed and still contribute to its continued existence.

Similarly, we may ask, did the architects of the Centre Georges Pompidou in Paris, a structure in iron and steel, foresee that people would feel the challenge to scale the sides with their scaffolding-like appearance, or that the forecourt of this futuristic building would become the venue for the most primitive forms of human entertainment – fire-eating, juggling, tumbling, and so on – and that this spectacle would entirely colour the way in which the building and its contents would be viewed? The tension set up between technological sophistication and time-honoured human amusements, and the visual contrasts between cast-iron solidity and the great flowing masses of humanity that surge in the huge and undivided court, is one of the most striking aspects of the building. The human presence may be said to make the building and is not, necessarily, any more ephemeral than steel and paint.

So we need to ask ourselves why we have chosen our particular object and whether we are asking the right question about it. Our approach is coloured by our epoch. We can easily ask purely academic questions about St Benoît-sur-Loire because it is remote in time and, perhaps to many, also in belief and function. We know, however, that the art historian of seven hundred years from now who approached the Centre Georges Pompidou simply as an academic exercise would have missed the whole point. We need to have an awareness of the meanings that Medieval monastic churches have in our own culture: timelessness, continuity, order and tranquillity might be some of them. And from there we need to go on to ask ourselves why these qualities are of particular interest (whether acknowledged or not) to scholars and audiences at the present time.

4

The Language of Art History

The language of art itself is not verbal; the visual artist communicates with us through colour, shape, mass, line, brushwork, texture, space and all the other elements that may be employed in any one artwork. Yet, if we wish to communicate to others our experience of any work of art we must use words. The very fact that I instinctively speak of 'the language of art' is evidence of the fundamental role of words in our culture. Pictorial images were certainly used before the written word but socialized humanity has for hundreds of years used words to convey delight in visual, literary and musical experiences. Our understanding of art and how it works is contingent upon our use of language and our understanding of how that works.

The person writing or speaking about a poem or a novel is using the same medium as the original under discussion. Someone communicating on the subject of music or the visual arts uses a literary medium. In all cases some kind of special language, a meta-language, is developed in order to communicate the subtleties, strengths and weaknesses of what is under discussion. Without this meta-language, the art historian must go a long and roundabout way to establish his or her point. There are, however, dangers inherent in special terminology devised or developed according to the needs of certain disciplines. The most obvious of these is that language will become so specialized that the meaning is inaccessible to anyone who has not learned it stage by stage. Notice, for example, in the passage below on Cézanne the words and phrases in italic which are 'short-cut' ways used by the writer in an effort to establish what he sees as changes apparent in the artist's work. Many of them would require explanation for a reader who was not already familiar with art-historical terminology.

49

The *shut-in masses* of the houses and of the terrain in the *foreground* still remind us of the *walled type of painting* of the preceding years, and especially of the 'Railway Cutting', but the lightness of the colouring is not *impressionistic*, it already contains essential characteristics of Cézanne's specific *colour treatment*. This is true also of the later pictures from this period, in which the *block-like solidity* is abandoned and the *looser construction* and lighter colouring represent a distinct approach to *impressionistic effects*: in proportion as the *contours*, the *modelling* and *chiaroscuro* are replaced by the *homogeneous impressionistic brushwork*, the *structure of the colouring*, based on small component parts, acquires a new *solidity*. In the course of Cézanne's development, a constant return to his own older *forms* and a juxtaposition of different methods of painting are characteristic, and this peculiarity, which makes the arrangement of his works in chronological order so difficult, is particularly frequent in the works which he produced from about 1874 to near the end of the seventies. In the famous *still-life* with the fruit-dish in the Lecomte collection, which can be dated at the end of the seventies, we have probably the first picture in which Cézanne achieves his *ultimate pictorial form*. Naturally his art undergoes plenty of changes even after this, but we can nevertheless speak of a certain *definitiveness*, for the most important principles of *representation and form* remain from this time on unaltered.[1]

All disciplines have a special language. The literary critic or historian writes of 'bathos', 'rhythm', 'couplet', 'satire', 'noun' and 'adjective', while the music critic or musicologist may refer to 'sonatas', 'cadences', 'chords' and 'rhythmic pattern'. It is important to notice that many of these terms are common to different areas of artistic experience. Words like 'rhythm' or 'cadence' may be used to describe lines in a poem, a musical sequence or an area of a painting. It is necessary to distinguish between the use of a word like 'rhythm' to define a particular and very specific musical phenomenon (as in 'contrapuntal rhythm', for example) and its metaphorical use when a writer describing a building or a painting wishes to invoke a regularity of repeated elements which we experience in music (as in 'the rhythm of the nine-bay façade with its giant pilasters', for example).

If we are tempted to dismiss the whole of this discussion by declaring that verbalizing about the visual arts is pointless because, had the artist believed their artistic statement could best be made in prose or verse instead of paint they would have chosen that medium, or because it is the materiality of art that is its statement and words are irrelevant, it is worth reminding ourselves that language is fundamental to our creative life as individuals. It enables us to communicate one with another. Some would argue that the formation of our identities individual and social depends upon it. It is, moreover, the all-pervading medium of academic and cultural debate at whatever level and in whatever circumstances. Language is used by a group of people after a wrestling match to communicate and compare their experience of the show just as it is by a group attending a private view at Marlborough Fine Art. Writing seriously about any subject is a creative act in itself and requires a skill and awareness that are consciously and deliberately acquired.

Going back to Novotny's passage on Cézanne's development, we see the meta-language of Art History in use. A word like 'chiaroscuro' which is borrowed from Italian and used widely in European writing on History of Art means literally 'brightdark' and is employed to describe the variations in tone from dark to light in a painting. But Novotny does not put it in italics because it is fully absorbed into the meta-language. Certain terms like 'still-life' and 'impressionistic' belong to the visual arts because they were originally coined to describe particular kinds of painting. We may also find them employed metaphorically to describe literature or music. In general, language is a vast common pool and, excepting strictly technical terminology, words are shared by the humanities disciplines. Consider, for example, these statements:

> In the storm music into which the ensuing trio is incorporated, brilliantly atmospheric music whose economy of means is again masterly, Verdi by a stroke of genius uses the humming of an off-stage chorus to represent the sound of the wind, thus anticipating Debussy by half a century. *Graphic phrases for flute and piccolo represent lightning.*[2]

The first works of a young poet are more frequently expressions of the intent to be a poet than exercises of a poet's

powers. They are also, almost necessarily, derivative; in
Keats's case the influence of Spenser is pervasive, not the
homely, English, and moral Spenser, *but the cultivator of
the enamelled and the musical.*[3]

'Graphic' means, in dictionary terms, 'pertaining to writing',
'delineating' or 'diagramatically representing'. Yet in Osborne's
description we can easily apprehend, if we listen to the music he
is writing about, the quality of vividness that distinguishes the
notes of the flute and the piccolo in the final act of Verdi's opera
Rigoletto. In the second passage, 'musical' does not surprise us as
an adjective since poetry is an oral medium dependent on sound
as music is. But 'enamelled' is a different matter. The writer is not,
we assume, thinking of a 'vitrified coating applied to a metal
surface and fired' (the dictionary definition) but wishes to convey
to us, rather, a decorative object in the manner, perhaps, of the
Limoges enamellers who used the technique we now employ for
making functional saucepans to create luxury art objects in the
late Middle Ages. He therefore assumes in his writing an under-
standing of historical relevance and comparability. He is using
'enamelled' in a visual sense to describe words but the sense is also
that which would have been understood by Spenser writing in the
sixteenth century.

Most of this book has been taken up with a discussion of the
problems encountered in the academic study of visual objects and
works of art expressed in non-verbal media. It may seem odd in a
book on Art History to devote an entire chapter to language but,
as art historians, we stand to lose if we neglect the verbal language
of our discipline. Reviewing an art-historical study, one critic
described History of Art as 'a discipline of pseudo-cultural
barbarity'. He had just been looking at *The Basket of Wild
Strawberries*, painted by the French eighteenth-century artist
Chardin, which he describes as 'a shape of strawberry scarlet
flanked by cherries and a peach, two carnations and a glass of
white wine, I suppose, which reflects the strawberry colour'.

'Is there,' the writer demands, 'anything which art history, as
practised, could advance to make this strawberry masterpiece
more effective, more resonant? Facing it . . . do we need more than
our eyes and our general notion of art?'[4]

This statement begs many questions. What, for example, is a
'general notion of art' and how does someone acquire it? Does the

writer mean to imply that there is some kind of perfect alternative Art History which is not practised but could be, given the right people and the right circumstances? However sympathetic one may or may not be to these criticisms of art historians, the answer to Grigson's final question, 'Do we need more than our eyes and our general notion of art?' faced with a masterpiece by Chardin, has to be YES, we do. We need language for the author, himself, in a stumbling way, is struggling to convey to the reader through linguistic means his experience of a painting. He declines to describe the picture. We do not know how the various items, strawberries, peach, carnations, cherries and glass are arranged one in relation to another, nor whether they are all on one plane or in the foreground or in the background, nor their relative size, nor the overall colour, which would be no more than a beginning if we were trying to tell someone who had never seen this picture what it looks like.

Grigson endeavours to translate a fragment of vision into words. It might be said that he is not concerned with telling us what the picture consists of, only with conveying what he saw. Nevertheless, that he feels impelled to do this testifies to our dependence on linguistic communication. The fact is that he did need more than his eyes, he needed words to describe what he saw though even these he has endowed grudgingly.

A Chardin still-life is undoubtedly a visual experience of sheer delight which nobody in their senses would wish to underestimate. The richer the experience, the subtler the operation of the work of art, the more complex its history, the more innovative the medium or the mode of expression, the greater will be our need for a direct but accurate language.

It is, of course, impossible ever to describe a work of art utterly objectively. Some element of interpretation is bound to intrude. But since analysis, evaluation and any kind of discussion depend upon our ability to communicate what we have seen to others, linguistic skills are essential to the art historian. In previous ages, before the advent of multiple photographic reproductions in books and magazines, the greatest responsibility of the critic and art historian lay in describing the appearance of works of art and architecture. Indeed the earliest art historians adopted a particular mode of rhetoric called *ekphrasis* to praise the visual through the verbal. In the nineteenth century when newspapers began to be more widely available page after page of the popular press was

filled with verbal evocations of pictorial art for the benefit of those who could not attend exhibitions. In some cases, these descriptions possess intrinsic literary qualities which entitle them to be considered as works of art in their own right. Here, for example, is the French critic, Denis Diderot, a contemporary of Chardin, writing about another of the artist's still-life paintings. His description was for circulation to an international circle of cultivated aristocrats rather than for the public at large.

The one you see as you walk up the stairs is particularly worth your attention. On top of a table, the artist has placed an old Chinese porcelain vase, two biscuits, a jar of olives, a basket of fruit, two glasses half filled with wine, a Seville orange, and a meat pie.

When I look at other artists' paintings, I feel I need to make myself a new pair of eyes; to see Chardin's I only need to keep those which nature gave me and use them well.

If I wanted my child to be a painter, this is the painting I should buy. 'Copy this,' I should say to him, 'copy it again.' But perhaps nature itself is not more difficult to copy.

For the porcelain vase is truly of porcelain; those olives are really separated from the eye by the water in which they float; you have only to take those biscuits and eat them, to cut and squeeze that orange, to drink that glass of wine, peel those fruits and put the knife to the pie.

Here is the man who truly understands the harmony of colours and reflections. Oh, Chardin! What you mix on your palette is not white, red or black pigment, but the very substance of things; it is the air and light itself which you take on the top of your brush and place on the canvas.[5]

We could not see precisely what Diderot saw if we looked at the picture he describes but we can, nevertheless, learn much from writers like Diderot in the eighteenth century or Hazlitt in the nineteenth: men who acquired their linguistic skills without the aid of photographs to remind them and their readers of the appearance of objects – about the power of language to describe as well as to interpret what is seen. The original passage is in French but even in translation it retains much of its gusto and individuality. We may not wish to cultivate the declamatory tone of Diderot but there is, on the other hand, no reason why writing

about art (or indeed writing about literature or biology) should not exploit all the subtleties our language has to offer and give pleasure to the reader as well as enlightenment. The reason it relatively rarely does so is that it is extremely difficult to describe a work of art.

Here is an example of a description which, although the book in which it appears is lavishly illustrated with high-quality photographs, is nevertheless essential to the reader for, as the author says, the painting 'is so much in need of cleaning that a description becomes necessary':

> A now almost obliterated column on the left descends to a plinth over which the curtain is draped. The curtain tassel falls to the ground at Lady Wilmot's feet. On the left is a cradle with a sophisticated classical ornament – in the same style as the stool on which Lady Wilmot sits – with above it a hood over which drapery is slung. The lady has just seized up her child, and the sheets and pillows are left in disarray. Light meanders over bedclothes and comes to settle on Lady Wilmot's blue draperies and on the edge of the stool.[6]

Nicolson is here describing a portrait and he combines an inventory of the ingredients of the picture – column, cradle, stool, and so on – with an economic and measured quantity of information about the appearance of these elements ('sophisticated classical ornament', 'sheets and pillows . . . in disarray') and about the treatment by the artist of the subject of mother and child in an interior ('seized up her child', 'light meanders') in order to provide us with what he regards as the most important information in the most succinct form.

Writing about three-dimensional artworks, and especially those in unconventional media, poses special problems. This writer, describing an environmental creation by David Nash, a contemporary artist, conveys to us the function and the appearance of the work by describing precisely how it was made:

> His most recent work 'Wooden Boulder' is another such case where one needs to look hard for the subtle agency of the artist. It is an 8 cwt oak ball, which he took from a felled tree found on site. This, with the help of a chain saw, was cut in broad facets, and rolled over the edge of a small waterfall.

It lodged in a hollow within a rocky gully, half way down a whole succession of cataracts. The boulder rocks slightly in its cirque, and the water increases the kinetic effect, which is at its optimum when there is sufficient force for the water to hit the boulder and recoil sharply. Nash calls it jokingly his 'anti-fountain', as it is a reversal of the normal process whereby water is piped to an object and pumped upwards through it.[7]

The question of an accurate and objective description of a work of art is central to any discussion of the language of History of Art. Whilst acknowledging that even the most direct description is bound to be subjective and should, if it is to read convincingly, contain an element of personal response, the author's determination to offer and to assess all the visual evidence available should also be manifest in any serious verbal discussion of art. Differences of opinion about this leads to bickering of an unproductive nature among critics. Here, for example, is an extract from a review of an art-historical study:

> Cork reveals an often brilliant ability to transcribe the visual image into the written word, but he is inclined to rely on this skill too much for a work of the nature (and price) of *Vorticism*, and it is a technique which has its drawbacks. Frequently Cork sees (and describes) only what he wants to see. For example, Lewis's *The Crowd* (1914–15) 'seems almost' (a revealing combination of words) to 'approach the timbre of an elegy'. But it is at least arguable (and seems more than 'almost') that this painting looks forward to Lewis's philosophical views of the 1930s, and that it is not so much a gravestone, as a milepost in the evolution of Lewis's art and ideas.[8]

Linguistic skills reflect our perception of the world and thus, also, our perception of art. Different ways of writing about art are developed both because people see objects and their place in history variously and because they interpret differently what they see. It has been suggested that even within Europe, the writing of History of Art varies considerably in syntax and vocabulary from one country to another because within different cultures variant modes of perception are developed. Thus German descriptions of

buildings involve far more active verbs than comparable English descriptions, conveying, therefore, a more dynamic view of, for example, a cathedral.[9] A uniform language for Art History would be an impossibility even if it were desirable. Nevertheless, an awareness of linguistic differences is a prerequisite both to the understanding and to the writing of Art History.

So far we have talked mainly about descriptive language; the analytical and historical language of Art History can best be examined by, again, taking certain specific examples. Clearly we cannot hope for coverage within the constraints and intentions of an introductory book of this kind. The following examples have been selected because they typify different but commonly encountered modes of writing within the mainstream of art-historical studies as experienced by the majority of students in the early stages of their work. This is not to suggest that these are the only linguistic modes of expression for Art History or, necessarily, the best ones. In each case the passages under discussion are taken out of context so that some loss of meaning, and in some cases the introduction of an esoteric note that was not apparent in the entire and original text, is inevitable.

The first example is from a published lecture by John Shearman who is here defining style in relation to the meaning (in religious and historical terms) of an altarpiece depicting the Entombment by a sixteenth-century Italian artist:

There is no mistaking the abstraction of style in the Capponi altarpiece, but we need to define it. It is not stylization towards preciosity, and the forms are not markedly artificial, or idealized in any classicizing sense. It is, on the contrary, a schematization and simplification with which Pontormo had long experimented for clarity and expressive purpose alone. This is not an ambiguous picture, but one that is entirely explicit. It makes a very direct statement freed from 'accidents' of place, time or characterization, because the pathos Pontormo describes so very sensitively is not that of a contingency, but of a timeless mystery of Redemption, of Death and Resurrection. And so it is logical that the forms and their setting should be purified, or abstracted from the particular towards the general, to the extent that there is not a stone, not even a blade of grass on the ground, there is no longer the ladder of the cross in the preparatory drawing but

no more than a passing cloud to describe an environment, and there is no means of identifying any personality such as the Magdalene.[10]

Shearman starts with a statement: Pontormo's painting is abstract in style. The word 'abstract' is frequently flung about quite indiscriminately but this author does not evade the responsibility of defining the word although the terms that he uses ('preciosity', 'idealized', 'classicizing', 'schematization') are likely to strike the inexperienced reader as themselves requiring definition. For Shearman, the 'abstraction' of Pontormo's style results from the suppression of the particular details of the Entombment as described in the Bible in order that the doctrinal and spiritual significance of the event can be better conveyed. As the painting represents a number of human figures and the body of Christ, the sentence 'the forms are not markedly artificial' suggests that the author intends us to understand that the human body is not treated in an unnatural way. 'Idealized in a classicizing sense' presupposes that his reader is familiar with the concept of the ideal, the perfect human form made up of an amalgam of individual parts rather than studied from one model, that was a commonplace in antiquity and in the revival of antique art that took place during the Renaissance in Italy. Pontormo's 'schematization and simplification' are comprehensible enough even without the earlier examples from his work that are implied in this sentence because the author qualifies his statement by telling us clearly for what purpose the artist developed this process.

John Berger, writing about a Russian twentieth-century sculptor, offers his reader a combination of passionate response and political didacticism. He begins with a description but one that lacks definition because it is emotional. Having caught the attention thus, he proceeds to use the work of art to make various points about humanity and society generally:

The *Hermaphrodite Torso* is a more complex and less seductive work than *The Stride*. It is an assembly of limbs and parts – a man's legs, a womb of space, a woman's breast, the shoulders of a machine. Unlike the *Adam*, this has little to do with the affirmative pleasure of sex, but far more to do with the sensation of effort, with the struggle for survival. As the variation of its parts suggests, it transcends the individual. If

the terms had not been abused in the usage of false moralities, I would say that it represents – but in terms of the fantastically resilient and vulnerable human body – the family, the nation, the human race. Its polarity, as always, is taut between life and death, between the breast and the cavity, between the tensed thigh and the rent abdomen. This is how men die in battle thinking of their children. This is how children are massacred before their helpless parents. This is what joins men together in resistance: a resistance which, if false ideologies are discarded and rendered undeceptive, we can find in the body itself.[11]

Like Shearman, Berger is anxious to stress the universal quality of the art he is discussing. Both authors establish the transcendence of the general over the individual, but here the similarity ends. Shearman's passage carries certainty (some might say dogmatism) and relies upon historical and stylistic evidence. Berger's response is intuitive and speculative ('this has little to do with . . .', 'I would say . . .') and his writing is not without inconsistencies. In the second sentence he refers to 'a womb of space', suggesting procreation but later he draws up a set of polarities which places 'death' and 'the cavity' alongside each other in opposition to 'life' and 'the breast'. The interplay between 'womb' and 'death' may be intentional but it is not clear that this is so. The language is emotive and conveys the reader with speed and passion away from the work of art to the consideration of 'false moralities', 'false ideologies' and 'resistance'. Even if we agree with Berger that we can find this last quality in the body itself, we are still left unsure of how the *Hermaphrodite Torso* can take us there. Berger's conviction is indisputable but it is born of the certainty of his own beliefs rather than of certainty before the work of art which is his starting point.

The word 'iconography' is frequently to be found in art-historical writing. Simply, it means the art of illustration and Iconology is the study of visual images. An icon originally meant a portrait but the term iconography is now more broadly applied to any group of visual images that possess a specific and identifiable literary meaning. Iconographical studies are usually characterized by a wide range of linguistic and cultural references as the writer traces the modifications and shifts in the meaning and form of an image through different ages and in different countries. The

language of this kind of writing can be obscure and present
considerable difficulties even to an experienced reader. Writers
often assume, quite unreasonably, not only a knowledge of
several foreign languages but also an extremely broad cultural
background. This passage is from one of Erwin Panofsky's
books; it is typical of iconographical Art History in that the
passage quoted occupies in the published text only a quarter of the
space of one page, the other three-quarters being taken up with
long and detailed footnotes in support of the assertions made in
the text:

> In the *Abduction of Europa* as in the *Death of Orpheus*, then,
> Dürer had gained access to the Antique by retracing what
> may be called a double detour: an Italian poet – perhaps
> Politian in both cases – had translated Ovid's descriptions
> into the linguistic and emotional vernacular of his time, and
> an Italian painter had visualized the two events by setting in
> motion the whole apparatus of Quattrocento *mise-en-scène* :
> satyrs, Nereids, cupids, fleeing nymphs, billowing draperies
> and flowing tresses. It was only after this twofold transfor-
> mation that Dürer was able to appropriate the classical
> material. Only the landscape elements – trees and grasses,
> hills and buildings – are independent of Italian prototypes;
> and the way in which the space is filled, from beginning to
> end, with *tätig kleinen Dingen* is thoroughly Northern, in
> spite of the fact that many of those 'busy little things' are
> classical satyrs, she-Pans and Tritons.[12]

The key to the language and the meaning of this passage of
writing lies in the words of the first sentence 'Dürer had gained
access'. An iconographic argument is only convincing if the
writer can persuade his reader that the artist in question could
have known or seen certain 'prototypes'. From these the whole
chain of connection stems. There are a number of linguistic clues
in this passage to the sort of scholarly method that is being
employed. Notice the reference to 'a double detour', suggesting a
complicated journey, and to 'linguistic and emotional vernacular',
an abbreviated way of describing a complex literary transform-
ation.

The characteristic argument of the iconographical study stems
from a wide range of learning; thus the writer's main problem is

how to put his material over to a reader unpractised in History of Art. Panofsky endeavours to overcome this problem in two ways. In the first place he divides his material into two sections; it is possible to read only the text, to take for granted that he has sufficient supporting evidence for the suggestion that it was possibly Politian who translated Ovid into the 'linguistic and emotional vernacular of his time'. On the other hand, the scholarly reader may refer to the footnote on this subject which occupies two-thirds of the page below the text. In the second place, Panofsky assists his reader to a certain extent by offering complementary clauses. We may not know that 'Quattrocento' is the Italian way of describing the fifteenth century, the 'fourteen-hundreds', we would say. We might have difficulty with *'mise-en-scène'* and might quite reasonably ask why the author, since he is writing in English, could not simply say 'stage setting'. On the other hand, assuming that some of his readers will not know what constitutes a fifteenth-century stage setting, Panofsky proceeds to give us a list of some of the ingredients: satyrs, nereids, and so on. The German phrase in the last sentence is translated as 'busy little things' which makes one wonder whether, although the phrase serves to remind us that we are dealing with a northern, German artist, it was really necessary in the first place. My penultimate passage deals not with a particular work of art, with its antecedents, its associations, its special qualities, but with a period of history. This writer employs no specialist vocabulary and no meta-language of Art History; his writing is, nevertheless, deliberate and controlled and makes an effect through conscious linguistic manipulation:

In the decades after 1848, the examples of Courbet and Baudelaire, and the different responses to politics they embody, stayed obstinately alive. It is curious how many of the best artists, later in the century, tried to combine those responses, however at odds with each other they seemed. Manet in the 1860s, for example, paying homage to Baudelaire's disdain for the public life, but aping Courbet's, and hoping against hope – or so the viewer feels face to face with *Olympia*, or looking on at the *Execution of Maximilian* – for a public picture, a picture to state exactly what its audience did not want to know. Or think of Seurat in the 1880s, keeping silent about politics, in spite of the anarchism

of his friends, staking his claim to artistic precedence with all the pedantry of a later avant-garde; but producing the *Grande-Jatte* or the *Chahut*, images of joyless entertainment, cardboard pleasures, organized and frozen: pictures of fashion, and thus of the place where public and private life intersect.[13]

The language of Art History is here the language of the present, the language of continuity. At least, that is the effect the author seems to be endeavouring to achieve. The construction of the first sentence is striking, dealing as it does first with the period, then with the two individuals Courbet and Baudelaire both established as representative of a 'response to politics' and, finally, with the continuity of this response which is expressed with an active verb in the phrase 'stayed obstinately alive' which one associates more usually with a person than with a response. It is the use of active verbs and, frequently, the present tense that gives this passage its persuasive power, its sense of a continuous process: 'embody', 'paying homage', 'hoping against hope', 'looking on' (a phrase which suggests succinctly both the way in which we as viewers look at Manet's *Execution of Maximilian* and the relevance, the contemporaneity, of the event portrayed in the picture), 'staking his claim' and 'producing'. Various words are used by Clark provocatively. 'Best' artists, for example, is likely to arouse vigilance in the reader though few would disagree that Manet and Seurat, and the examples of their work that follow, are good artists and successful paintings.

Clark exploits the capacity of language to surprise by leading the reader to expect one thing but then giving the opposite or, at least, the unexpected. The reader wants to know in the third sentence what Clark means by public but the definition of a 'public picture' which is provided, 'a picture to state exactly what its audience *did not want to know*' (my italics), is the inverse of what might have been expected. In many ways the language of this art-historical writing is challenging; it is also not without ambiguity. Indeed, Clark exploits ambiguity. In the last sentence of the passage, it is not clear whether 'cardboard pleasures, organized and frozen' is a description of the content of Seurat's paintings or the style and technique in which they are executed. The author does not distinguish between subject and style because both are understood. Perhaps most important is the evident

determination of this author to avoid art-historical jargon. The linguistic problems raised by the use of words like 'politics', 'public and private' remain but at the very least this writing is accessible to someone outside the discipline of History of Art.

In the final selected passage the author attempts to explain the salient characteristics of an artist *and* of writing about that artist by analysing how certain motifs function as signs within a system of meaning that is not contained within the pictures themselves. The language here derives from Linguistics:

> In Watteau, a whole narrative structure insists on meaning but at the same time withholds or voids meaning. Let us take the example of this characteristic theatrical costuming. In the theatre, such clothing is part of a general system of conventionalised costumes with exact dramatic and signal-ling functions. The diamond-patterned costume signals Arlequin, the baggy, white, ruffed costume signals Ped-rolino or Gilles, the black cap and gown signal the Doctor. But outside the frame of the stage, in a *fête champêtre*, such signalling costumes lose their semantic charge, and having lost that original meaningfulness take on all the sadness of depleted signs. Again, the configuration which appears both in the musical analogy and in the biographical emphasis of the Watteau literature: a sign that insists on a signified which is absent, disconnected from the present signifier, at the same time that sign makes the claim for a powerful and attractive signified (melancholy) that is nowhere stated in the painterly signifier.[14]

In this passage the reader confronts the language of semiology; the meta-language of Art History has been replaced by that of Structuralism ('a whole narrative structure') and it is applied not to a particular work or group of works but to an artist. The object of study is no longer a particular painting nor is it, in the conventional sense, the life and work of Watteau. Bryson is concerned with exposing the relationship between what we know of Watteau from the way he has been written about ('the biog-raphical emphasis of the Watteau literature') and what we see on the picture surface. Somewhere between the two a meaning is pro-duced. The question is how? The sadness of Watteau's paintings has always been acknowledged but Bryson tries to explain this

without recourse to the subjective response of the individual viewer (e.g. this picture has a sad feel to it; it makes me feel sadness). To do this he treats the ingredients of the picture's stories as signs for something outside the picture. The theatrical clothes *signal* certain meanings on the stage which, Bryson indicates, is as much an artificial structure as a picture ('the frame of the stage') but those meanings are lost when the context is a country picnic (*fête champêtre*). It is characteristic of semiological analysis to discard the notion of a painter making a meaning, embodying it within an image. In this passage the subject of the active verbs is not the artist but the narrative structure which means not only the painting as object but the frame of reference in the world in general ('the whole narrative structure insists . . .'). The reference to 'the sadness of depleted signs' suggests the kind of absurdity and bathos that semiologists dealing with visual material can fall into. Nevertheless in employing a system of analysis which makes a distinction between an image on a canvas ('the signifier') and the meanings it carries ('the signified') Bryson is able to theorize a problem in Watteau, that is, to point to an underlying principle at work which, it is argued, accounts for the recognized mood of the paintings.

Notes: Chapter 4

1 Fritz Novotny, *Paul Cézanne*, Vienna, 1937, pp. 18–19. My italics.

2 Charles Osborne, *The Complete Operas of Verdi*, 1969, p. 257. My italics.

3 William Walsh, 'John Keats', in *From Blake to Byron*, Pelican Guide to English Literature, ed. B. Ford, 1957, p. 224. My italics.

4 Geoffrey Grigson reviewing *Romanticism* by Hugh Honour, *Guardian*, 29 March 1979, p. 10.

5 D. Diderot, on J. B. S. Chardin, 'Salon of 1763', trans. and repr. in L. Eitner (ed.), *Sources and Documents in the History of Art: Neoclassicism and Romanticism*, 1971, p. 58.

6 Benedict Nicolson, *Joseph Wright of Derby, Painter of Light*, 1968, p. 74.

7 Hugh Adams, 'The Woodman', *Art and Artists*, April 1979, p. 46.

8 Robert Cumming, review of Volume II of Richard Cork's *Vorticism and Abstract Art in the First Machine Age*, *The Burlington Magazine*, May 1977, p. 359.

9 K. R. Lodge, 'The Language of Art History', March 1979, pp. 77–9.

10 John Shearman, *Pontormo's Altarpiece in S. Felicita*, The Charlton Lecture, 1968, Newcastle, 1971, pp. 25–6.

11 John Berger, *Art and Revolution, Ernst Neizvestny and the Role of the Artist in the USSR*, Harmondsworth, 1969, p. 149.

12 Erwin Panofsky, *Meaning in the Visual Arts* (1955), Harmondsworth, 1970, pp. 284–6.

13 T. J. Clark, *The Absolute Bourgeois, Artists and Politics in France 1848–1851*, 1973, p. 181.

14 N. Bryson, *Word and Image: French Painting of the Ancien Régime*, Cambridge, 1981, pp. 71–2.

5

The Literature of Art History

As foreign travel and the mass media have aroused increasing interest in the visual arts in our own century, museums, galleries and commercial dealers in artworks have multiplied and, correspondingly, so has the literature of art. A bewildering array of books on art has become available although, ironically, it remains difficult enough to find bookshops prepared to stock any range in the more serious art books. This chapter is intended as a guide to the classes and types of art-historical literature that the sixth-form student or the first-year undergraduate is likely to encounter. The literature of History of Art naturally reflects the diversity of approach to the subject discussed in Chapter 2. Here, however, we are not concerned in any way to discuss the content of books that are mentioned or to assess the merit of any particular work. In so far as titles and authors are mentioned, they have been chosen only because they provide suitable examples of certain classes of literature.

Locating a copy of the book one wants to buy, borrow or consult is a perennial problem for the art historian. With increased numbers of students and increased prices of books, finding an available copy of a necessary text is a problem for most students today. Because books on art are more expensive than those on most other subjects the problem is particularly acute for the student of History of Art. Even supposing that the reader can afford to buy a copy of the required book, unless one of the specialist art bookshops like Blackwell's in Oxford, the St George's Gallery at 8 Duke Street, St James's, London SW1 (just off Piccadilly), or Zwemmer's at 24 Litchfield St., London, is near at hand, it may be necessary to place an order and that can delay receipt of a copy.

Several London galleries (for example, the Tate Gallery, the Hayward Gallery and the Victoria and Albert Museum) have extensive bookstalls where a whole range of commercially produced art publications are for sale as well as the catalogues of their own collections and exhibitions. Certain paperback series of art books, for example, the Thames & Hudson 'World of Art' books and the Pelican series 'Style and Civilization' as well as best-sellers like Gombrich's *The Story of Art* and John Berger's *Ways of Seeing* are normally to be found in any good bookshop.

The economics of the book trade is not our concern in this work, but, in passing, a word of warning seems appropriate. Art books with good colour plates cost a great deal of money to make and their production is still regarded by publishers as special catering for a small audience. Once art books are out of print it is often quite difficult to persuade a publisher that a reprint would be worthwhile and even texts which are widely used in educational establishments have been known to be out of print for years. This can be a real problem though it is encouraging that several firms now specialize in reprints. Garland of America is one and the Scolar Press in England who publish facsimiles (that is, exact photographic reproductions of original editions) is another.

What about libraries, then? No library has an unlimited budget and, as the price of books has risen, libraries in any one area have tended sensibly to pool their resources and to consult each other about expensive purchases, thus ensuring that two copies of a book sold at £150 (not so unusual in 1985) are not required in the same geographical region. It may be necessary, therefore, for a student living in an area where there is perhaps a university library, a polytechnic library and a public library to telephone around in order to locate a particular work.

Most university and polytechnic libraries are 'teaching' libraries. That is to say that their holdings reflect the needs of the courses that are taught there. There are, of course, exceptions like the library of the Courtauld Institute of Art, the University of London, which is more in the nature of a reference library. Increasingly as undergraduate dissertations and theses (individual projects on which students work under supervision) become the norm rather than the exception, the libraries of polytechnics and universities find it difficult to cater for all the needs of students. Many of the special reference libraries like the British Library or

the National Library of Scotland do not normally offer facilities to undergraduates but many big cities now possess good specialist art reference libraries. Manchester, Leeds and Birmingham, for example, all have well-stocked art sections in their central libraries and for those in the London area there is the National Art Library situated in the Victoria and Albert Museum (currently undergoing repair and reorganization) as well as art sections at some public libraries like Westminster Central Reference Library.

Reference books

These can be divided roughly into three groups:

(1) Those that give biographical information about artists listed by name.
(2) Encyclopaedias which contain entries on selected artists and also on techniques, monuments, frequently used terms and important places.
(3) Bibliographies.

Neither of the best-known publications in the first group is in the English language. Nevertheless, even someone entirely ignorant of French or German can usually make some sense of the entries with intelligent use of a dictionary. The works in question are U. Thieme and Felix Becker, *Künstler Lexicon*, published in Leipzig between 1900 and 1970, and Emmanuel Bénézit, *Dictionnaire critique documentaire des peintres, sculpteurs, dessinateurs et graveurs . . .*, of which the most recent edition was published in Paris in 1976. Unfortunately neither the English-language Penguin *Dictionary of Artists* nor the *Oxford Companion to Art* is an adequate alternative but the *Dictionary of National Biography* can be of use to a student seeking information on an English artist born before 1900. *The Dictionary of Art* which Macmillan plan to publish in 28 volumes simultaneously in 1991 should fill the gap and provide an up-to-date reference book.

In the second group there is a large choice of publications. It is worth remembering when using these reference works that a production like the *Encyclopedia of World Art* (New York, 1959–68), which is to be found in most art libraries and also in many non-specialist public libraries, is a compilation of short essays by different writers and it will, therefore, vary in quality and style from one entry to another. In all cases entries are bound

to be selective and to reflect the opinion of the editors as to which artists were 'important' at the time the work was being written. Encyclopaedias like this are published over a long period of time and entries will, inevitably, be dated by the time the volumes appear in print.

Encyclopaedias of art can be very useful as long as their limitations are realized and they are not used to enable the student to produce a quick 'potted' essay on an artist. It is important to realize, for example, if using the *Enciclopedia Universale seda dell'Arte Moderna*, published in Milan in 1969, that the editor's concept of what constituted 'modern' art may not correspond to ours.

One of the features of the *Enciclopedia Universale* is its lavish colour illustrations. A similar production, but with a wider scope, is the fifteen volumes of *Les Muses*, published in Paris in 1969. Ideally it is desirable to consult several such reference books rather than just one alone because in one case the entry may contain the fullest documentation, in another the author may have concentrated on giving examples of an artist's works and listing their whereabouts, in a third the emphasis may be on high-quality colour illustrations.

There exist also reference books which provide information on sale prices and exhibitions. There are directories of museums and art galleries, dictionaries and glossaries of terms used in different areas of art, classified indexes of signs and symbols and dictionaries of reproductions, to name but a few. The sixth-former or the undergraduate may find it helpful to become acquainted with these.

The third group of publications is essential for the research student but can also be very profitably used by someone studying History of Art at a much less advanced level. For example, if a student wished to know where to read about an artist whose work is so recent that his name has not yet found its way into any of the dictionaries or encyclopaedias, he or she could search in the *Art Index* for references to articles in journals or reviews of exhibitions and thus build up a bibliography or list of publications about the artist. The *Art Index*, published quarterly from 1929 in New York, covers archaeology, art history, arts and crafts, photography, film, planning and all subjects related to the visual arts. Illustrations, even when there is no accompanying text, are also indexed.

The *Répertoire d'Art et d'Archéologie*, published in Paris from 1910, is similar to the *Art Index* but, as it is organized in sections by period sub-divided by country (with indexes according to artist, subject and author at the end), it is particularly useful if one has forgotten the name of the artist one is looking for but knows the country and the period, or if one simply wants to see what books or articles have been published on, say, ivory carving in the Middle Ages or twentieth-century painting in Poland. *Artbibliographies* MODERN is a similar research tool, published twice a year from Oxford and documenting (since 1972) the literature covering the history of art, architecture and design from 1800 to the present.

RILA ·

General histories

The general historical survey of the arts of a period can be a very useful aid to the student of History of Art providing the constraints under which the author is writing are clearly understood by the reader. The longer the period covered in a general art-historical survey, the less detail there will be. There was a tendency at the beginning of this century with the development of art-historical studies to attempt to cover whole centuries at a time. A. Venturi's *Storia dell'Arte Italiano*, published in Milan in 1901–40, consists of twenty-five volumes which are the work of numerous collaborators. It would now be used by students of the Renaissance in conjunction with more specialized studies. The very titles of more recent works on the period indicate the degree to which authors now feel it necessary to define their subject precisely. Thus, for example, Michael Baxandall's book on Renaissance art, dealing with a scrupulously defined area, is called *Painting and Experience in Fifteenth Century Italy: A Primer in the Social History of Pictorial Style* (Oxford, 1972), whilst a recent American contribution to Renaissance art-historical studies by Janet Cox-Rearick is entitled *Dynasty and Destiny in Medici Art* (Princeton, 1984).

When reading general surveys it is helpful to ask oneself why the author has started at one particular date and cut off at another. One should also remember that just because a particular artist has not been dignified by virtue of an appearance in a survey, this does not necessarily mean that he or she is unimportant or uninterest-

ing. Interpreting events that have taken place over a period of
time, discerning a pattern in the past, is as complicated and
difficult as interpreting particular works of art or understanding
the life, aims and methods of a particular artist. There is an air of
the definitive and inclusive about a book like R. Rosenblum and
H. W. Janson's *Art of the Nineteenth Century: Painting and
Sculpture* (Yale, 1984) which (for all its usefulness) may seduce the
inexperienced reader, may persuade him or her that whatever is
found there represents the whole that can be said.

It has been argued (by G. Pollock and and R. Parker in *Old
Mistresses: Women, Art and Ideology*, Routledge and Kegan Paul,
1981) that surveys like these have written women artists out of the
history of art. A further criticism might be that they tend to
concentrate on Western art and overstress post-Renaissance art.
Hugh Honour's and John Fleming's *A World History of Art*
(Macmillan, 1982) makes, however, an impressive attempt to
balance East and West, Ancient and Modern.

Alongside the general histories, there are books on 'isms' or
studies in artistic movements or developments that have been
conveniently labelled (usually by critics rather than by participat-
ing artists) for posterity. Books on all the popular and familiar
movements of modern art – impressionism, fauvism, cubism,
surrealism – are available by the dozen. They vary enormously in
value as regards both the content of the text and the quality of the
illustrations. Extreme care is necessary in the choice of these
books. It is difficult to lay down hard and fast rules but there are
two useful criteria. In the first place any serious study of a
movement in art should include a more than anecdotal discussion
of the critical history of the period or group (in other words, what
was said by critics and the public about the works of art and how
the artists came to be given this particular name). In the second
place, a worthwhile and successful study of a movement in art
does not seek to establish uniformity at the expense of contradic-
tion and variety. Anyone who has looked at the activities and
creativity of a group of artists at any one period of time recognizes
the problem that frequently faces the historian. All the particip-
ants seem so various, so eccentric, so individual that one is bound
to ask, whatever did they have in common? The question is simple
but the answer is complex. The art-historical study that seeks to
iron out differences or to ignore paradoxes in the interests of a
neat explanatory account must be suspect. For example, any

study of impressionism that lacks a very serious evaluation of the *differences* between the objectives and methods of Monet, Renoir and Pissaro should be regarded with the deepest suspicion.

It is appropriate to mention a third type of book in this section. This is the study of style. In some cases books on movements in art are at one and the same time studies of style but it is important to distinguish here the book which deals less with a movement that can be located historically in time than with common characteristics in the appearances of works of art. For example, most serious studies of the late nineteenth-century European style known as *art nouveau* include (whether they convince us or not) a consideration of the possible origins or antecedents of this style in the curvaceous forms of eighteenth-century rococo or the convolutes and scrolls of medieval illuminated manuscripts.

Monographs

A monograph is a book which concentrates on one artist or one monument whether it be a building, a painting, a sculpture or a series of paintings. For example, a typical monograph would be Larry Silver, *The Paintings of Quintin Massys* (Phaidon, 1984). Paul Hayes Tucker's book *Monet at Argenteuil* (Yale University Press, 1983) is also a monograph for although the frame of reference is very wide, covering the history of a town, its industry and development, the focal point remains Monet and his perception of that environment. The subject of John Gage, *Turner's Rain, Steam and Speed: The Great Western Railway* (1972) is the genesis and execution of one single painting but in discussing this the author covers the critical, philosophical and historical background in which the work of art came into being. The Italian publisher Rizzoli is responsible for a series of books (some of which are translated into English) on the complete works of an artist. The volumes have the general title *Classici dell'Arte* and they reproduce cheaply and in small format all the known works of an artist.

Monographs which deal with the work of highly productive artists are often published in several volumes. For example, Sir Anthony Blunt's *The Paintings of Nicholas Poussin* (1966–7) is in three volumes: a text, a critical catalogue of the paintings of Poussin and a volume of illustrations. It is important to acquire

the technique of using books like this as reference tools, picking
out the parts needed at any particular stage of study. For this it is
essential to be able to use an index and that may not be a simple
affair. For example, Blunt offers the following in his *Critical
Catalogue*: a bibliography arranged chronologically from 1627 to
1966 (when the volume went to press), an alphabetical index to
the bibliography, an index of extant* paintings by, after† or
attributed to Poussin arranged according to collection (i.e. where
they were at the time the catalogue was compiled), an index of
subjects by genre (i.e. portraits, religious subjects, and so on) and
an index of persons and places. Learning to find what you need in
a book like this requires persistence and practice.

This is, perhaps, a suitable point at which to introduce the
problem of illustrations. If colour plates of one and the same
painting in several different books are compared, enormous
variations in colour are to be seen. We should not need to remind
ourselves how important it is not to rely on reproductions for our
experience and knowledge of works of art. However, it is perhaps
useful to realize that some books specialize in high-quality colour
reproductions. The Swiss firm Skira, for example, has produced
many fine collections of colour plates. On the other hand, there
are monographs which have been produced very economically
and in which the reproductions are few and of poor quality. It is
usually possible in a library to use these two kinds of books in
conjunction.

The illustrations in any one art book are all more or less of a
similar size, their dimensions being naturally dictated by the
format of the book. It is, therefore, extremely important con-
stantly to bear in mind when reading an illustrated art book that
the objects photographed are of varying dimensions. Some may
be gigantic and some tiny but they will appear in the pages of the
book as more or less uniform. Any serious art-historical study
will include the dimensions of the work of art along with infor-
mation about the medium (stone, metal, oil on canvas, fresco, and
so on) and the location either underneath the illustration or in a
separate list of illustrations. It is a good idea to carry an expanding
tape measure and to make a point of always looking at the
recorded dimensions of a work of art and, provided its measure-

* Still in existence.
† Copies of Poussin's work by other artists.

ments allow, not merely envisaging its actual size in one's head but also working out how much space it would occupy.

Catalogues

There are two main types of scientifically presented catalogue of works of art with full historical and physical documentation provided. On the one hand there is the critical catalogue of one artist's work of the sort we have already mentioned in connection with Blunt's monograph on Poussin. This is often referred to as a *catalogue raisonné* or 'reasoned catalogue'. On the other hand, there is the catalogue that is published by a museum or art gallery on chosen groups of works in its permanent collection. These are usually selected according to period, school and medium. For example, one catalogue may document miniature paintings, another seventeenth-century Dutch drawings.

A catalogue entry should contain, in compressed form, all the important factual information available at the time of publication about any one of a group of works of art. The accompanying illustration (on the next page) shows one entry from a typical catalogue of a national collection. Keith Andrews, *National Gallery of Scotland: Catalogue of Italian Drawings* (Cambridge, 1968). Although there are slight variations in format from catalogue to catalogue, in general the 'decoding' process is the same. As new information becomes available, catalogues are revised and supplements are published.

Exhibition catalogues

During the last twenty years, exhibition catalogues have become more detailed, more thoroughly researched, better illustrated and increasingly indispensable to the art historian. They do, of course, vary enormously, but many exhibition catalogues from public galleries and museums are not only extremely informative but also very economical to purchase. In principle, the exhibition catalogue entry performs some of the functions of the *catalogue raisonné* entry but usually with less detail. An exhibition catalogue offers not information on, for example, all the Italian drawings in the National Gallery of Scotland, but documentation

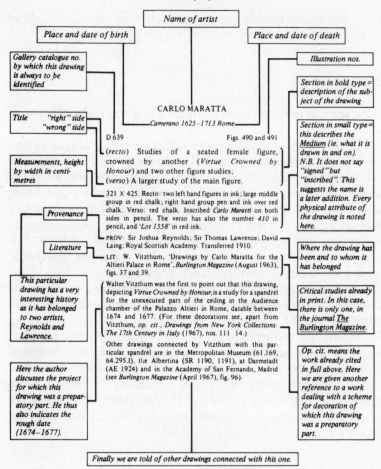

Name of artist

Place and date of birth

Place and date of death

Gallery catalogue no. by which this drawing is always to be identified

Illustration nos.

Section in bold type = description of the subject of the drawing

CARLO MARATTA

Camerano 1625–1713 Rome

Title "right" side
 "wrong" side

D 639 Figs. 490 and 491

Section in small type = this describes the <u>Medium</u> (ie. what it is drawn in and on). N.B. It does not say "signed" but "inscribed". This suggests the name is a later addition. Every physical attribute of the drawing is noted here.

Measurements, height by width in centimetres

(recto) Studies of a seated female figure, crowned by another (*Virtue Crowned by Honour*) and two other figure studies; (verso) A larger study of the main figure.

321 × 425. Recto: two left hand figures in ink; large middle group in red chalk; right hand group pen and ink over red chalk. Verso: red chalk. Inscribed *Carlo Maratti* on both sides in pencil. The verso has also the number *410* in pencil, and '*Lot 1558*' in red ink.

Provenance

PROV: Sir Joshua Reynolds; Sir Thomas Lawrence; David Laing; Royal Scottish Academy. Transferred 1910.

Where the drawing has been and to whom it has belonged

Literature

LIT: W. Vitzthum, 'Drawings by Carlo Maratta for the Altieri Palace in Rome', *Burlington Magazine* (August 1963), figs. 37 and 39.

Critical studies already in print. In this case, there is only one, in the journal <u>The Burlington Magazine</u>.

This particular drawing has a very interesting history as it has belonged to two artists, Reynolds and Lawrence.

Walter Vitzthum was the first to point out that this drawing, depicting *Virtue Crowned by Honour*, is a study for a spandrel for the unexecuted part of the ceiling in the Audience chamber of the Palazzo Altieri in Rome, datable between 1674 and 1677. (For these decorations see, apart from Vitzthum, *op. cit.*, *Drawings from New York Collections: The 17th Century in Italy* (1967), nos. 111–14.)

Other drawings connected by Vitzthum with this particular spandrel are in the Metropolitan Museum (61.169, 64.295.1), the Albertina (SR 1190, 1191), at Darmstadt (AE 1924) and in the Academy of San Fernando, Madrid (see *Burlington Magazine* (April 1967), fig. 96).

Op. cit. means the work already cited in full above. Here we are given another reference to a work dealing with a scheme for decoration of which this drawing was a preparatory part.

Here the author discusses the project for which this drawing was a preparatory part. He thus also indicates the rough date (1674–1677).

Finally we are told of other drawings connected with this one.

on works of art that have been assembled for display from collections both public and private all over the world. The subject of the exhibition may be an artist, a period, a theme or any one of a great variety of other things. There will probably be an introductory essay or essays as well as the entries. It is sometimes the case that an exhibition catalogue is the only item in print on a particular artist.

Ideally one should visit the exhibition with the catalogue but, even long after an exhibition is over, the catalogue remains a rich source of interest and enjoyment. We may gain some idea of what

the exhibition catalogue has to offer by looking at a couple of examples.

The 1970s saw a series of 'blockbusting' exhibitions in European capitals devoted to themes and involving works in a wide range of media. *The Age of Neo-Classicism* was the fourteenth exhibition of the Council of Europe (1972). It was a very large exhibition dealing with the revival of Grecian and Roman art in Europe in the eighteenth and nineteenth centuries and covering most aspects of the visual arts: architecture, furniture, ceramics, painting, drawing, and so on. There are 1,912 entries in the catalogue, many of them long and informative. Not surprisingly, there are few illustrations but the reader is offered eleven essays ranging from 'Neo-classicism in the French Revolution' to 'Goethe and the contemporary fine arts' by scholars of different nationalities.

Clearly, nobody could have been expected to read all the essays and absorb all the information in the catalogue entries while actually looking at the exhibition. The catalogue is not merely a handbook to the exhibition. It is a text on the period under consideration, a work of reference.

As with all catalogues of large exhibitions, a certain amount of ingenuity and perseverance is required by the reader of *The Age of Neo-Classicism*. Because this particular exhibition was the result of international collaboration, the reader has to work through the names of the exhibition advisory committee, the international committee, the steering committee, a long list of acknowledgements and nine pages of foreword before he reaches the first essay. The architecture section is provided with an index and there is also an index to the names of artists and craftsmen in the furniture section and to lenders. In other parts of the catalogue the reader has to search through the appropriate section for any particular entry.

Quite a different reading experience is offered by *Alberto Giacometti: A Retrospective Exhibition*, the catalogue of an exhibition looking back over the life and work of the sculptor Giacometti (this is what 'retrospective' means) held at the Solomon R. Guggenheim Museum, New York, in 1974. Here we are offered the work of one sculptor in a format that stresses the element of personal encounter. The catalogue is of manageable size, every item in the exhibition is illustrated with a black and white photograph and the whole production bears the stamp of

one organizer. Whilst *The Age of Neo-Classicism* offered the
virtues of an international colloquium or debate about the differ-
ent facets and manifestations of a style, *Alberto Giacometti* invites
us to experience the development of one person's art as seen by
another person. This is not to say, however, that *Alberto
Giacometti* is less useful as a text and a reference work than
Neo-Classicism or that now that the sculptures shown in the
exhibition have long since returned to their respective owners the
catalogue will be forgotten.

After a short summary of acknowledgements we have a photo-
graph of Giacometti which immediately establishes the bio-
graphical emphasis which is sustained throughout this catalogue.
'Form and vision, the work of Alberto Giacometti', an essay by
Reinhold Hohl, complete with notes, follows, and then each of
the 217 works in the exhibition is listed with an appropriate
catalogue entry and a photograph. Next comes a selected bibli-
ography subdivided into works by the artist, conversations with
the artist (in English) and studies by critics and art historians:
monographs, critical essays and publications with important
reproductions, films. There follows a list of selected exhibitions
and a chronology (important dates in the sculptor's life and work)
and, finally, photographic credits. The last item is more than a
formality or a courtesy; it enables the reader to see from what
sources he may acquire photographic prints of works in the
exhibition.

Studies in iconography

The study of iconography is the study of images. Books on
iconography usually take a specific theme and trace variations in
the presentation and meaning of that theme in the work of
different exponents within a given period of time. Many studies in
iconography bear titles which sound alarmingly learned and very
remote from everyday experience. Take for example, H. W. Jan-
son, *Apes and Ape Lore in the Middle Ages and the Renaissance*
which was published in London by the Warburg Institute in 1952
and which contains chapters on, among other subjects, 'The ape
in early Christianity' and 'The ape in mediaeval science'. Such
studies, however, introduce the relative newcomer to the excite-
ment of the 'treasure hunt' aspect of the discipline. They are often

more accessible to the general reader than at first appears, especially if he or she is not arrested by long, scholarly footnotes.

Iconographical study is not confined to the Middle Ages and the Renaissance although the programmed use of emblems and symbols in the art of these periods is particularly suited to the approach. There are, for example, many iconographical studies of twentieth-century art for the same method may be applied to any image or set of images. J. Adler, *The Bachelor Machines* (New York, 1970), in which the iconography of the machine in the twentieth century is the subject of discussion, is one such study.

One way of becoming familiar with the language of pictorial symbol is to consult a dictionary of iconography such as *Hall's Dictionary of Subjects and Symbols in Art* (1974) whilst remembering that what is true for dictionaries of words is also true for dictionaries of images, that the precise meaning depends on context.

Theory

Sooner or later the student of History of Art will encounter a scholarly study of art theory. The form this often takes is an examination and assessment of the beliefs and practices that provided the rationale for an artist or group of artists. One of the most celebrated of such studies is Rudolf Wittkower, *Architectural Principles in the Age of Humanism* (1949). Another example of this class of art-historical literature is Albert Boime, *The Academy and French Painting in the Nineteenth Century* (1971).

At one level, such books may provide an introduction to the period that is being studied since they deal with fundamental questions of ideology and principle. Nevertheless, there is much to be said for approaching them only after one has familiarized oneself to some extent with the appearance of the art of the period in question. Indisputably these are the sort of books which the art historian finds it profitable to read again and again. In an important sense it is true to say that the more visual and literary experience one possesses the more one can hope to extract from a book of theory.

The same applies to books that deal with the philosophy of art, with aesthetics (the study of the human response to certain recognized visual phenomena), and with the psychology of per-

ception. Some of these are essential reading for the art historian but, although tempting to the beginner who wants to 'know all about ART', they can be very difficult and should be returned to and mulled over as greater experience is acquired. The readily assimilable style of writing in, for example, E. H. Gombrich, *Art and Illusion: Studies in the Psychology of Perception* (3rd edn, 1968) may to the hasty reader seem to belie the extremely complex nature of the ideas and evidence contained in the book.

During the 1980s we have seen an increase in publications that cut across the established art-historical categories of the mono-graph, the catalogue raisonné and the historical survey. Critical studies addressing particular problems and issues within a given period, studies that consciously employ a particular stated method, have contributed to a rigorous approach to history within the discipline of Art History and focussed attention on the problematic relationship of the artist to history. Svetlana Alpers's *The Art of Describing* (John Murray, 1983) employs a methodol-ogy influenced by French historians of knowledge to explore northern seventeenth-century art and science. Her arguments challenge conventional ways of 'reading' Dutch genre painting. Serge Guilbaut, on the other hand, in *How New York Stole the Idea of Modern Art: Abstract Expressionism, Freedom and the Cold War* (University of Chicago Press, 1984) examines the politics of avant-gardism in a particular historical context, draw-ing on the kinds of arguments that historians of imperialism have employed in recent years and applying them to cultural produc-tion.

Books on techniques

The most important books on technique are, as far as the art historian is concerned often those which have been written by artists themselves. Treatises like Leon Battista Alberti's *Della architectura, della pittura e della statua* (originally published as three separate books but available as a collection in English translation since 1755), Leonardo da Vinci's *Trattato della Pittura* and Cennino Cennini's *Il Libro dell'Arte* (all of which are available in modern English translations) are a mine of infor-mation on the techniques and practices of Renaissance painters and, since their authors did not hesitate to digress into anecdote, they are also very entertaining reading.

Many worthwhile and interesting books on technique were published during the second half of the last century when the creation of national museums in many European capitals lent impetus to scientific and analytical studies of the material of art. Despite its disconcertingly long title, Mrs Mary Philadelphia Merrifield's book *The art of fresco painting as practised by the old Italian and Spanish masters with a preliminary inquiry into the nature of the colours used in fresco painting, with observations and notes* (1846) is readable and informative and, as it exists in a reprint of 1952, is not as inaccessible as at first might appear.

These older books should be consulted and read alongside the more recent reference works on the subject of materials. Perhaps the best-known of these is Max Doerner's *The Materials of the Artist and their Use in Painting with Notes on the Techniques of the Old Masters* (1976, translated and revised). Books that originated as exhibition catalogues for works in particular media have also become useful general texts. Two examples are Marjorie B. Cohn, *Wash and Gouache: A Study of the Development of the Materials of Watercolour* (The Center for Conservation and Technical Studies, Fogg Art Museum and the Foundation of the American Institute for Conservation, 1977) and Susan Lambert *Drawing: Technique and Purpose* (Trefoil Books, 1984).

Journals

Journals that publish articles on art, Art History and visual communications present nowadays a confusing and bewildering array. There are at least three ways of using them. In the first place students may wish to look at a particular article in a current or a back number which deals with some aspect of their work. In the second place, browsing through a whole range of recent or current numbers of journals on the stands in a library is a worthwhile way of getting an idea of what the latest research has to offer. In the third place reading the same journal month by month or quarter by quarter enables you to become familiar with editorial policy and to have the chance of following an ongoing debate through successive issues.

It would be very difficult to classify the journals in Art History and it should be noticed that many journals that do not specifically address the visual arts carry articles from time to time that may be of great importance to art historians. Among them would be

Victorian Studies, History Workshop Journal, Feminist Review, British Journal of Aesthetics, Past and Present, Radical Philosophy, Screen and *Scientific American.*

If we consider those journals that specialize in visual communications we might usefully isolate the glossy, large format international magazines which carry substantial amounts of advertising for the art trade and specialize in high quality reproduction. Best known among these would be: *Apollo, The Burlington Magazine, Connoisseur, Gazette des Beaux-Arts* and *Leonardo*. Distinguishable from these would then be those journals with a smaller circulation, less advertising and, arguably, an editorial policy that was in general more attuned to contentious ideas and less attuned to attribution studies. Many of these are edited from within institutional Art History departments and they would include: *Block, Word and Image, Art and Text, Oxford Art Journal, October* and *Representations*. All of these, typically, concern themselves with communications in the broadest sense and possess something of an interdisciplinary character.

The journals named here publish at least a proportion of their articles in English (there are many others that are, of course, in other languages) and most are completely in English. There are also journals that are the organs of particular associations though available also on the open market. Examples of these would be *Art History* (the journal of the Association of Art Historians) and *Art Bulletin* (the journal of the College Art Association of America). Also included would be the *Journal of the Walpole Society* and the *Journal of the Royal Institute of British Architects*.

A final group to note would be those journals and magazines that specialize in contemporary art practice. The best place to find them is on the bookstalls of the Tate Gallery and the Institute of Contemporary Arts. They would include *Flash Art, Art News, Art Monthly* and *Artscribe* to name but a few.

Useful Addresses

The following addresses and telephone numbers are correct at the time of publication. As information of this kind can become out of date quite rapidly you are recommended to consult the *Arts Review Yearbook* (published by *Arts Review*, 16 St James's Gardens, London W11) and the *Museum Yearbook* (published by the Museum Association, see below).

Arts Council of Great Britain, 105 Piccadilly, London W1V 0AU (01-629-9495). The Arts Council will supply information about current and forthcoming exhibitions. A *Directory of Arts Centres in England, Scotland and Wales*, is published by the Arts Council in association with the National Association of Arts Centres.

The Scottish Arts Council, 19 Charlotte Square, Edinburgh 2 (031-226-6051).

The Welsh Arts Council, 9 Museum Place, Cardiff (0222-394711).

Art Services Grants Ltd., 6 & 8 Rosebery Avenue, London EC1R 4TD (01-278-7751). This organization comprises the Air Gallery which shows the work of lesser-known artists, Space Studio provision which finds studios for artists in the London area and the ASG monthly newsletter. The organization will supply information on artists of whom it has knowledge and an index of slides of the works of artists who have been connected with the organization can be consulted at its headquarters by appointment.

Association of Art Historians, Secretary Joseph Darracott, 18 Fitzwarren Gardens, London N19 3TP. The Association organizes annual and occasional conferences, publishes a bulletin and a quarterly journal, *Art History*. Reduced subscription rates are available to students.

British Association of Friends of Museums, Hon. Sec. Mrs R. Marsh, 66 The Downs, Altrincham, Cheshire WA14 2QJ (061-928-4340). The Association offers advice to those who wish to set up Friends groups in support of museums, galleries, cathedrals and historic houses, other buildings of historic or architectural importance and gardens of outstanding beauty. The Association's policy is to increase the element of voluntary help in museums wherever possible.

British Film Institute, 127 Charing Cross Road, London WC2 (01-437-4355).

Civic Trust, 17 Carlton House Terrace, London SW1Y 5AW (01-930-0914). The Trust encourages the protection and the improvement of the environment. By means of conferences, practical projects, films and reports it focusses attention on major issues in planning and architecture. It publishes a bi-monthly newsletter and maintains a library and photographic collection. Information about local amenity societies can be acquired from the Trust's registry. The Trust also administers the Architectural Heritage Fund which

provides loan capital to local buildings preservation trusts and, on behalf of the Historic Building Council, government aid to non-outstanding conservation areas.

Civic Trust for the North West, 65 Oxford Street, Manchester M1 6EU (061-236-7464).

Civic Trust for the North East, 34–35 Saddler Street, Durham DH1 2NU (0385-61182).

Scottish Civic Trust, 24 George Square, Glasgow G2 1EF (041-221-1466).

Civic Trust for Wales/Treftadaeth Cymru, Welcome House, Llandaff, Cardiff CF5 2YZ (0222-567701).

Contemporary Art Society, Organizing Secretary, Petronilla Spencer-Silver, 20 John Islip Street, SW1P 4LL (01-821-5323). The Society is mainly a fund raising body. Subscriptions and money raised by outings and foreign tours as well as private views goes towards the purchase of contemporary art for presentation to public collections.

Crafts Council, 12 Waterloo Place, London SW1Y 4AU (01-930-4811). The Council exists to promote Britain's artist-craftsmen. Its aim is to help them maintain and improve their standard, sell their work and to become better known to the public. At the Council's headquarters an Index of craftsmen can be consulted and there is a collection of 8,500 slides in the library.

Design Council, 28 Haymarket, London SW1Y 4SU (01-839-8000). The Design Council promotes the improvement of British Design. Its tasks include the creation of a greater awareness of design and the demonstration for educational purposes of advances in design by British companies.

Design History Society, Membership Secretary Joan Skinner, 69 Willowbrook Road, Leicester LE5 0FG (0533-59307).

Educational Foundation for Visual Aids. The Foundation sponsors the *National Audio Visual Aids Centre*, q.v.

English Tourist Board, 4 Grosvenor Gardens, London SW1W 0DU (01-730-3400). The Board can sometimes provide useful information about historic sites and houses open to the public.

Scottish Tourist Board, 23 Ravelstone Terrace, Edinburgh EH4 3EU.

Wales Tourist Board, Brunel House, 2 Fitzalan Road, Cardiff CF2 1UY (0222-499909).

Federation of British Artists, 17 Carlton House Terrace, London SW1Y 5BD (01-930-6844). The Federation sponsors exhibitions by younger or deserving painters to enable them to become better known to the public. It provides a central source of information on contemporary art matters and provides a forum for the arts.

Furniture History Society, c/o Dept of Furniture and Woodwork, Victoria and Albert Museum, London SW7 2RL (01-741-1461). The Society was founded to study furniture of all periods, places and kinds, to increase knowledge and appreciation of it, and to assist in the preservation of furniture and its records. It publishes *Furniture History* annually and arranges annual lectures, occasional visits, an annual conference and weekend courses.

Garden History Society, 66 Granville Park, London SE13.

Georgian Group, 37 Spital Square, London E1 6DY (01-377-1722). All buildings designed in the classical manner come within the scope of this pressure group's activities. Reduced subscription rates available to those under 18.

Gulbenkian Foundation, 98 Portland Place, London W1N 4ET (01-636-5513). The Foundation sponsors artists in residence at a variety of institutions and will provide information about this programme.

Historical Association, 59A Kennington Park Road, London SE11 4JH (01-735-3901). The Association is mainly for historians but it organizes conferences which are often of interest to art historians.

Historic Churches Preservation Trust, Fulham Palace, London SW6 (01-736-3054). Register and information about churches of architectural interest.

Historic Houses Association, 38 Ebury Street, London SW1W 0LU (01-730-9410). Information offered on many interesting houses which are in private possession.

Historic Buildings and Monuments Commission for England (English Heritage), Fortress House, 23 Savile Row, London W1Y 2HF (01-734-6010).

Institute of Contemporary Arts, Nash House, The Mall, SW1Y 5AH; postal address: 12 Carlton House Terrace, London SW1Y 5AH (01-930-3647). The Institute has a theatre, bookshop, cinema and gallery. Membership entitles a person to advance mailing of the monthly bulletin but the Institute is open to anyone on a daily charge.

Museums Association, 34 Bloomsbury Way, London WC1A 2SF.

Museums and Galleries Commission, 2 Carlton Gardens, London SW1Y 5AA (01-930-0995).

National Audio Visual Aids Centre, Paxton Place, Gipsy Road, London SE27 (01-670-4247).

National Film Archive, 81 Dean Street, London W1 (01-437-4355).

National Heritage, The Museums Action Movement, 9A North Street, Clapham, London SW4 0HN.

National Monuments Record (including National Buildings Record) Fortress House, 35 Savile Row, London W1X 1AB (01-734-6010). Library facilities and archive open to the public daily at Fortress House.

National Trust, 36 Queen Anne's Gate, London SW1H 9AS (01-222-9521). Details are available from the Trust about all National Trust properties, Young National Trust groups and under-21 group membership.

National Trust for Scotland, 5 Charlotte Square, Edinburgh EH2 4DU (031-226-5922).

Royal Institute of British Architects, 66 Portland Place, London W1 (01-580-5533). The Institute includes a library, a drawings collection and facilities for the sale of publications. The drawings collection is housed in Portman Square.

Royal Photographic Society of Great Britain, 14 South Audley Street, London W1Y 5DP (01-493-3967).

Scottish Film Council, 16–17 Woodside Terrace, Glasgow G3 7XN (041-333-5413).

Society for Education in Film and Television, 29 Old Compton Street, London W1V 5PL (01-734-5455).

Thirties Society, Sec. Clive Aslett, c/o *Country Life*, Kings Reach Tower, Stamford Street, London SE1 (01-261-6969).

Victorian Society, 1 Priory Gardens, Bedford Park, London W4 1TT (01-994-1019). Reduced subscription rates available to students. The Society is mainly concerned with the preservation and conservation of Victorian buildings but is also interested in aspects of the visual arts in the nineteenth century. Walks, visits, lectures and travel abroad are included in the annual programme.

Slides

If you are a teacher establishing a slide library you will find that the National Gallery, the Tate Gallery, the Victoria and Albert Museum, the British Museum and all the larger provincial museums and galleries sell slides through their publications departments. They are usually prepared to send a catalogue through the post. The Victoria and Albert Museum also runs a Slide Loan Service. The Resources Centre at Battersea Town Hall accommodates the Women Artists Slide Library. There are also many commercial firms and other organizations that sell colour transparencies of works of art. Among them are:

The Miniature Gallery, 60 Rushett Close, Long Ditton, Surrey KT7 0UT.

Icarus Slides, 158 Boundaries Road, London SW12 8H9.

The American Library Color Slide Co., Inc., PO Box 5810, Grand Central Station, New York, NY 10017, USA.

Scala s.p.a., Via Chiantigiana 62, 50011 Antella (Florence), Italy.

Audio Visual Productions, Hacker Hill House, Chepstow, Gwent NP6 5ER.

Focal Point Audio Visual, 251 Copnor Rd, Portsmouth (665249), are the distributors of the Sussex Art History Slide-Texts, a teaching/learning aid comprising original historical studies in the form of booklets accompanied by sets of twenty slides for each unit.

Some useful addresses outside Great Britain

CIHA (Comité Internationale d'Histoire de l'Art), Administrative Secretary, Alfred A. Schmid, Bd. de Pérolles 59, CH-1700 Fribourg, Switzerland.
The CIHA is the largest international organization for the history of art; it publishes a bulletin and organizes specialist symposia conducted in several European languages as well as a large conference once every three years.
College Art Association of America, 149, Madison Ave., New York, NY 10016, USA.
This is the professional organization for American art historians; it publishes the *Art Journal* and the *Art Bulletin* and organizes an annual conference and many other events.
International Center of Medieval Art (ICMA), Secretary, Leslie A. Bussis, The Cloisters, Fort Tryon Park, New York, NY 10040, USA, tel. (212) 928 1146.
International Federation of Film Archives, Secretary General, Ms. Brigitte Van der Elst, Coudenberg 70, B-1000 Bruxelles, Belgium, tel. 511.
Arts Council of Australia, 80 George Street, The Rocks, Sidney, New South Wales 2001, Australia.
Contemporary Art Society of Australia, POB 3271, GPO Sydney, New South Wales 2001, Australia.
American Association of Museums, 1055 Thomas Jefferson Street, N.W., Washington DC, Washington 20007, USA.
American Federation of Arts, 41, East 65th Street, New York, NY 10021, USA.
The Federation is a non profit-making organization with the aim of broadening knowledge and appreciation of the arts past and present.

INDEX

Index

Diane Tonkyn
Joanne L. – CAB

Marely Schiff · Contemp Can Art
Alfred Barr · on Mod. Art